IMAGES
of America

CASS COUNTY

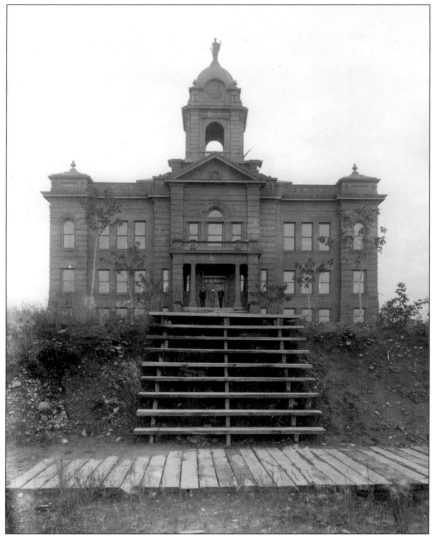

Construction on a new courthouse began in 1902. It took nearly five years to complete, and then the interior was still not finished when the building was dedicated on April 5, 1907. About 500 people assembled to witness the formal opening. A banquet was served, complete with the proper speeches, and a dance followed.

On the cover: Logging began in the Gull River area in Cass County in 1855. The first sawmill there was built in 1879. In 1893, a 16-foot sled was loaded with 144 tons of 18-foot white pine and hauled to an exhibit of the Chicago world's fair. It was the largest load ever hauled by one team. By 1895, one of the longest logging railroads in history was the grade from Cross Lake in Crow Wing County to Long Lake on the north side of Longville. Logging was at its peak in Cass County in the early 1900s. The last load of logs left by train during the summer of 1909. Logs were then dumped into Leech Lake. The last boom of Weyerhauser Company logs was sluiced through the Leech Lake dam at Federal Dam in June 1911. In the early 1920s, the big companies could find no more large tracts of timber to cut and subsequently moved their mills further west ending up in northern California, Oregon, and Washington. (Courtesy of the Cass County Historical Society.)

IMAGES
of America

CASS COUNTY

Cass County Historical Society

ARCADIA
PUBLISHING

Copyright © 2008 by Cass County Historical Society
ISBN 978-0-7385-5207-1

Published by Arcadia Publishing
Charleston SC, Chicago IL, Portsmouth NH, San Francisco CA

Printed in the United States of America

Library of Congress Catalog Card Number: 2007941424

For all general information contact Arcadia Publishing at:
Telephone 843-853-2070
Fax 843-853-0044
E-mail sales@arcadiapublishing.com
For customer service and orders:
Toll-Free 1-888-313-2665

Visit us on the Internet at www.arcadiapublishing.com

*To the many hands and minds who made the Cass County Museum
a reality: Don and Dorothy Vollman, Willard Pehling, Cedric Schluter,
Glenn and Gwen Otteson, Babe Reid, Ardis Bilben, Leona Greer,
Mary Norton, Marion Orava, Herb and Jeanette Fisher,
Stan Johnson, and the past and present board of directors.*

CONTENTS

ACKNOWLEDGMENTS

Since the Cass County Museum was founded in 1948, dozens of volunteers have contributed their time to preserve the history of the county. Without their hard work and their love of local history, this book would not have been possible. The museum's research library, archives, newspaper microfilm, and photograph collections offer access to information that is difficult or impossible to find elsewhere. We would like to thank all the families and organizations that had the generosity and foresight to donate photographs and articles to the county museum so that they will be accessible to the public over the years. These donations are greatly valued and appreciated.

We would like to belatedly thank the town and neighborhood columnists who faithfully mailed in their weekly news to the county newspapers. These local columns added color and spice to the news and frequently provided details about people and happenings that were not recorded anywhere else.

All scans were done by Cecelia McKeig, owner of Relative Research and Cass County Historical Society board member. The bulk of the captions were written by Renee Geving, director of the Cass County Museum. Both worked during the off season without pay to make this publication possible.

Thanks to the Cass County Historical Society for providing the use of archival material, office equipment, and supplies. All the images in this book came from the archives of the Cass County Historical Society.

And once again, thanks to our families for accepting, if not quite understanding, our obsession with research and writing.

INTRODUCTION

Minnesota was still a territory in 1851 when the boundaries of Cass County were laid out, and it became one of the 10 counties that then existed in the Minnesota Territory. It remained a created county with no county officers until 1872, when it was first organized and its size reduced. In 1876, the Act of 1872 was repealed and the county was declared disorganized and attached to Crow Wing County for both record and judicial purposes. After a hard fought political battle, Cass County was finally organized again in 1897.

The Ojibwe of the area were part of the westward movement of the early 1700s. Arriving in what is now Minnesota, they had to contend with the powerful Dakota tribes living here. Warfare prevailed throughout the mid-1700s with the Dakota. It was at Leech Lake that the Dakota made their last stand against the Ojibwe and abandoned the area in 1748. However, the Dakota still made frequent raids on the Ojibwe of the upper Mississippi region until the Dakota uprising of 1862, after which all Dakota were expelled from northern Minnesota.

Fur traders were active in this region as early as 1760, when the French operated a post at Red Cedar Lake. The British fur traders had their posts in Minnesota from 1783 to 1812. Zebulon Pike headed a government expedition, which visited the British stockade along the Leech River in February 1806. About 1820, the American Fur Company also had a post on Red Cedar Lake and another post on Lake Winnibigoshish from 1823 to 1848.

In 1848, the Leech Lake Agency was established southwest of Agency Bay on Leech Lake. In 1865, the Ojibwe ceded a vast tract of land to the United States and reservations were established at Leech Lake, Gull Lake, Cass Lake, and Lake Winnibigoshish. Controversy between the Ojibwe and the federal government began in 1881 with the building of five dams to regulate the flow of the Mississippi headwaters. This unrest contributed to the conflict on October 5, 1898, at Sugar Point, which was the last Native American war in the United States. Mah-ge-gah-bow and Flat Mouth II were early spokesmen for the Ojibwe living at Bear Island and around Leech Lake.

The county seat was established at Walker in 1897 and named in honor of Thomas Barlow Walker, who had large lumber and land interests in the county. Steamboats cruised the waters of Leech Lake and Cass Lake. Towns were established, and churches and schools were built. The railroads stretched northward into the county. Logging reached its peak in the early 1900s. A land office was opened in Cass Lake in 1903. Newspapers spread the word about the excellent fishing and hunting in the region. The Minnesota National Forest was renamed the Chippewa National Forest in 1928. The Consolidated Chippewa agency was established at Cass Lake in 1922, and the Minnesota Chippewa Tribe was organized in 1934.

The photographs in this book do not provide a complete history of all facets of Cass County, but this collection of photographs and captions are the result of a sincere effort to reflect some of the county's history and character. From over 2,500 possible images, these were chosen to focus on the early years of the county's history. The photograph collection at the Cass County Museum is one of the historical society's greatest assets. These photographs are shared in the hope that they will bring knowledge and enjoyment to all those who turn the pages and share the memories with others.

One

NATIVE AMERICANS

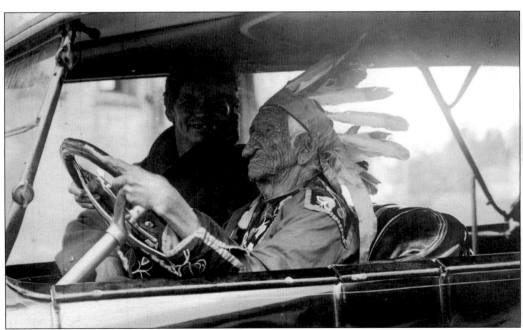

John Smith of Cass Lake, also known as Ka-Be-Nah-Gwey-Wence, was an Ojibwe man who reportedly lived in three centuries. Born around 1790, he lived to the ripe old age of 137 before death claimed him in 1922. His friends called him "Old Wrinkled Meat." He helped to promote the Pan car, which was produced in St. Cloud between 1919 and 1921.

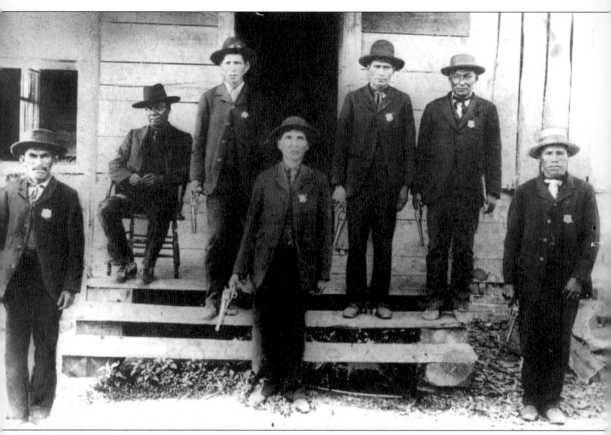

Deputy Marshal Bob Morrison attempted to serve a warrant on Bug-o-nay-ge-shig when he appeared for the annual payment at the Old Agency in Onigum on September 15, 1898. When this was unsuccessful and he fled back to Sugar Point, Native American deputies accompanied Deputy Marshal Mike Sheehan and army troops in an attempt to serve warrants on Bug-o-nay-ge-shig and his companions. An accidental discharge from a stacked rifle started the Battle of Sugar Point on October 5, 1898. Shown in the photograph are Sheehan's deputies. From left to right are R. Adams, William Bonga, unidentified, unidentified, Henry Martin, Joseph Bellanger, and Henry Bruce. At the battle site, William Russell, one of the Native American police, took a canoe and started across the lake. Sentries mistook him for one of the enemy and shot him through the back. He was the only Native American killed in the battle. One of the unidentified deputies may be Edward Warren, who was present at the battle and later owned a mercantile store and hotel at Federal Dam until his death in 1916.

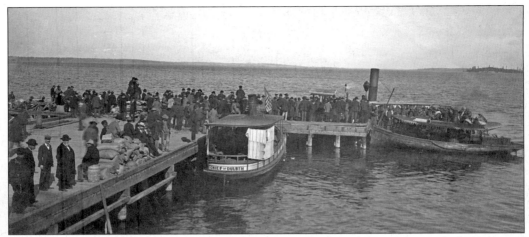

The *Chief of Duluth*, Thomas Barlow Walker's boat, was moored at the city dock. Barges at the front of the dock were ready to carry the soldiers to the battlegrounds at Sugar Point in 1898. Soldiers had spent a cold night near the city dock and boarded a little before the first light of dawn. The anchor and propeller are now located on the Cass County Museum grounds at Walker.

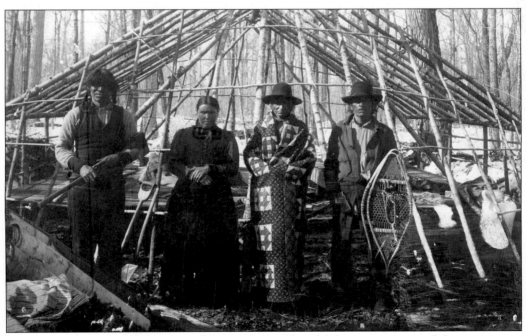

Bug-o-nay-ge-shig (right) disappeared during the battle and did not reappear until the next spring. He probably spent the winter with his brother Red Hair, Red Hair's wife, and Go-ne-wah-quod at Boy Lake. James S. Drysdale of Walker took this photograph on April 7, 1899, at Red Hair's abandoned maple sugar camp. Bug-o-nay-ge-shig eventually appeared in many Walker parades until his death on May 27, 1916.

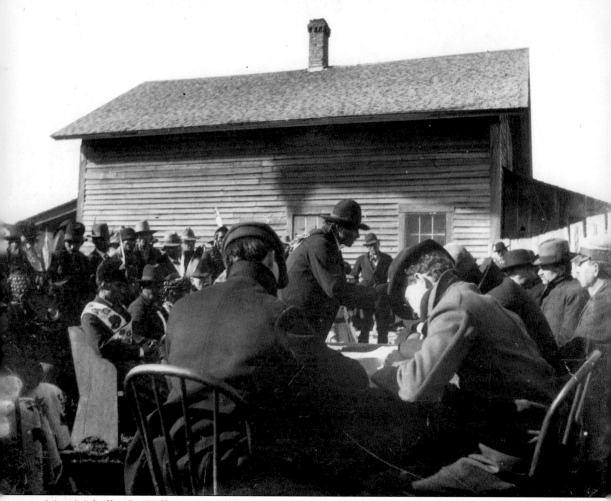

Maj. Melville C. Wilkinson and six enlisted men were killed in the battle of Sugar Point. Fr. Aloysius Hermanutz, a missionary at White Earth, immediately went to the Indian Agency near Walker to help negotiate a settlement with the Native Americans. Father Hermanutz, Gus Beaulieu, Joe Bellanger, and a Bear Island chief met with the Native Americans at Sugar Point on October 11, 1898. Peace talks began at the Leech Lake Agency on October 12, 1898, and continued daily. Native American Commissioner William A. Jones from Washington, D.C., personally met with the Native American delegation and was firm about the surrender of the men named in the warrants. Beaulieu, White Earth Agency interpreter, urged that all logging of dead and down timber be halted and a congressional act be passed to have all timber sold. On October 15, 1898, 25 Native American men published an address to the state and the country in which they expressed their regret over the death of the brave soldiers. The final council met on October 17, 1898. A force of soldiers stayed at Walker all winter.

Frank Briggs was a local barber and owned the Tonsorial Parlors at the Pameda Hotel in 1898. On October 6, 1898, a relief expedition left Walker to raise the siege at Sugar Point. Briggs went along on one of the steamers as one of the 30 volunteers to the battle site. Records indicate that the soldiers at Sugar Point had little or no extra provisions or ammunition. When the steamers backed away because the Native Americans were inflicting heavy gunfire on them, Briggs took a rowboat, loaded it with available supplies for the soldiers, and rowed it to shore. Under heavy fire, he returned with a wounded soldier and a rowboat nearly full of water from bullet holes from the Native American Winchesters. He received a commendation for bravery from the returning soldiers. This photograph was later taken by Quam and Drysdale Photography of Walker.

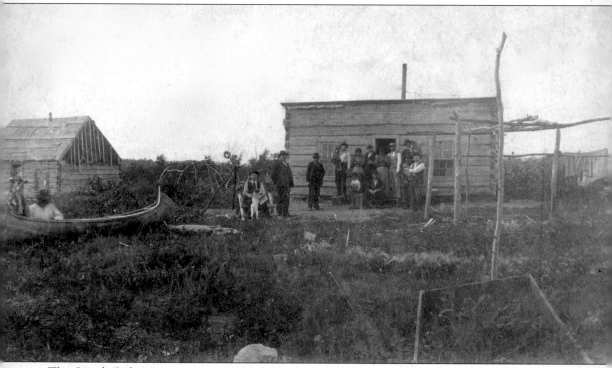

The Leech Lake Agency was established after the Ojibwe ceded a large area of northern Minnesota in the treaty of 1855. Congress appropriated funds for the new agency in 1856. Ojibwe laborers immediately built a wagon road connecting Leech Lake with Crow Wing about 65 miles due south on the Mississippi River. It was one of the first roads in the region. Rev. William T. Boutwell, the missionary in charge of the operation, bought land for the agency. He started the construction of several log buildings, including a mission house and blacksmith shop. The Ojibwe had mixed reactions to this settlement and some sought to keep outsiders away from the reservation lands. A council meeting was held at the agency in 1858 to air grievances and select a site for a new steam-powered sawmill. The Civil War brought a hiatus to the plans, but by 1865, the sawmill was up and running and more land was being cleared. Additional buildings were erected as the Leech Lake Agency grew in size and importance.

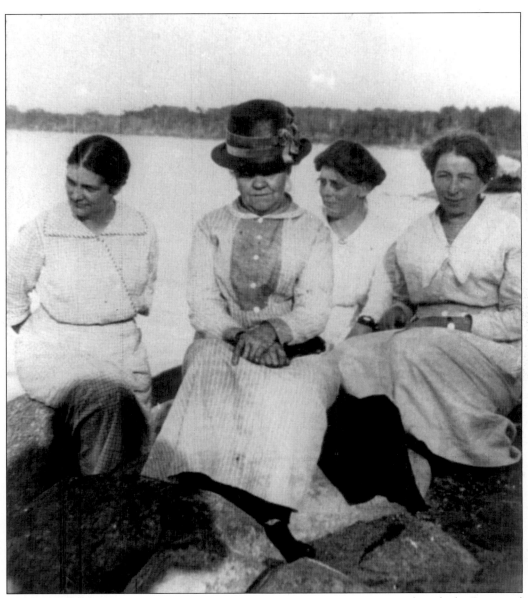

Pauline Colby (second from left) was born in 1853. She came from New York with the Episcopal Church and lived at Old Agency and then at Onigum from 1891 to 1915 where she taught lace making to the women. The idea was to provide employment for the women of the Chippewa tribe that would make them self-supporting. There was no market for the beadwork that they made at the time. The lace was sold in New York to such patrons as Mrs. Vanderbilt, Mrs. Astor, Mrs. Huntington, and Mrs. Pierpont Morgan. The Native American women received 10¢ an hour and were paid as soon as a piece was completed. Colby kept a journal of her experiences, titled, "A Missionary Journey to Minnesota in 1893, Related by Miss Pauline Colby to Frances Densmore." She died in St. Paul on January 22, 1944.

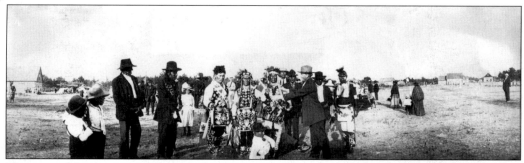

This is a celebration at the Leech Lake Agency in the early 1900s. The residents in and around the agency celebrated the Fourth of July with picnics, canoe and horse races, foot races, and a powwow. Walker townspeople were invited to participate and arrived by steamboat.

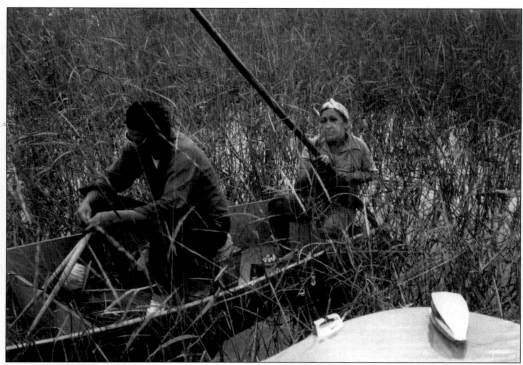

Wild rice, or "manoomin," is a water species of grain found from Manitoba to Florida and is a primary food source for the Ojibwe. Native Americans of the Leech Lake Reservation traditionally harvested wild rice with birch bark canoes in August and September. This was a time for giving thanks, community gatherings, and sacred feasts. Parched rice was easily stored and readily available during the winter months.

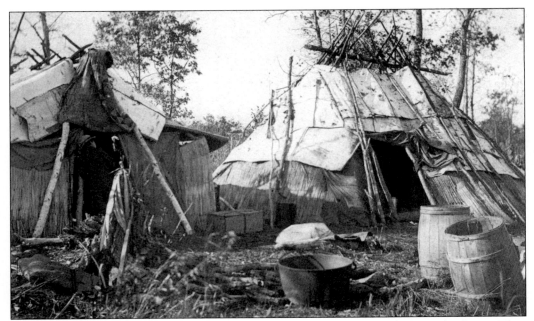

Ojibwe dwellings were constructed from birch bark and other materials from the forest. They were taken apart and the bark soaked and rolled so they could be carried to the next camping site. Heavy or bulky items were left behind to be used again when the people returned to the site. The cast iron kettle and the wooden barrels suggest that this encampment may have been a sugar camp.

In this Native American burial ground located on the Leech Lake Reservation near Old Agency, the structures are typical of the traditional burial custom of the Ojibwe people. When the house decomposes, the spirit crosses the river to the other world. The family often brought food and gifts to assist the spirit on his journey.

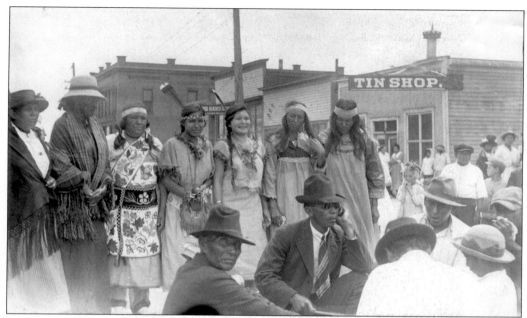

The Northern Minnesota Development Association held its convention in Cass Lake and invited the Northern Minnesota Sheep Growers, the Minnesota Scenic Highway Association, and the County Agents Association to join them. Convention activities were concluded with a powwow in June 1919.

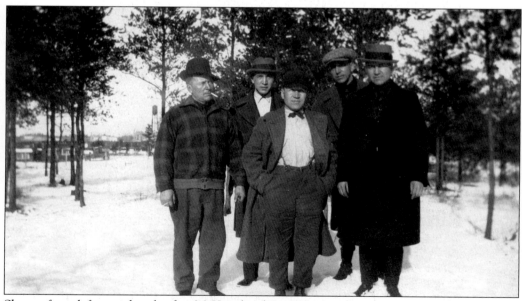

Shown from left to right, the five McKeig brothers, Barney, Simon, Jim, Ed, and Frank, were born to an Irish logging superintendent and an Ojibwe cook from White Earth. The brothers moved to Cass Lake and Federal Dam in search of work. Ed served in World War I and then returned to his job as brakeman and conductor until injured in a rail yard accident in 1951.

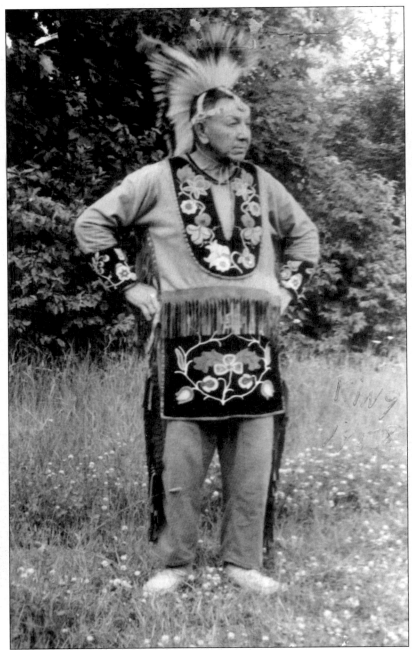

Peter King, or Maish-kow-e-gah-bow, which means "solid standing," was born September 4, 1895, on the White Earth Reservation. King was a member of the Mississippi band. He and his wife, Sarah, made yearly trips to Pipestone to bring back pipestone for ceremonial pipes. King always carried a pipestone pipe made by his wife. He danced at the powwow held every Saturday night in Walker during July and August in the 1950s and early 1960s and perfected eight original dances over the decades. His outfit was one of the oldest in the state, and the beadwork in his regalia was excellent. The horns that he used for his buffalo dance are on display at the Cass County Museum in Walker. He was a master of the traditional dance. He passed away on April 5, 1965.

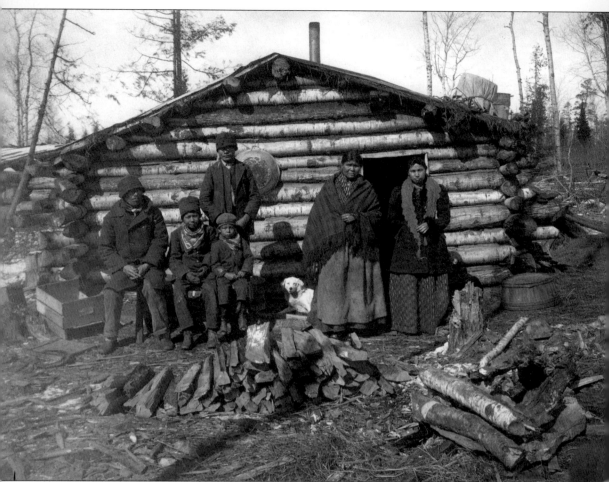

This Native American family is dressed against the cold. When the annuity payments were made at the agency in the fall, many Native American families went to the nearest mercantile store and purchased warm clothing and staples for the coming winter. The Ojibwe changed their residences according to the seasons of the year. Spring was the time to harvest maple sugar; summer was to gather fresh fish and berries that were then dried out in the sun; and wild rice was harvested in the fall. This dwelling is made of poplar and probably is a temporary shelter that was part of a sugar camp. Snow is still visible on the ground. Many Ojibwe men also worked with the government survey crews as guides and occasionally transported them throughout the area in their birch bark canoes. The concept of ownership and boundaries was a difficult one for these families who were accustomed to seasonal migrations.

Two

FORESTRY AND LOGGING

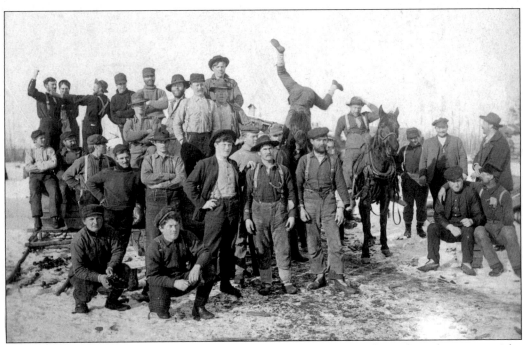

Many Cass County lumberjacks were single men from Norway and Sweden who came to the Midwest between 1880 and 1900. Some sent money home, but many lost touch with home folks and lived out their years as bachelors in area villages. When the logging industry moved west to Washington, Idaho, and Oregon, Alvin "Swede" Carlson, Lon Sutton, Jimmy McHugh, "Hungry Mike" Sullivan, and others like them stayed behind.

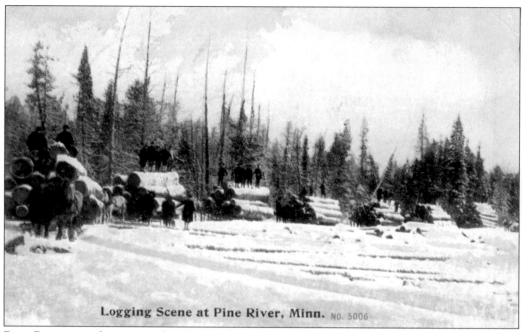

Logging Scene at Pine River, Minn. NO. 5006

Pine River was the scene of extensive logging operations in 1890. An average of between 5,000 and 10,000 feet came out of the six large camps in the area. Sluice dams located at the Pine River outlet at Norway Lake and another between Sand and Hattie Lakes were built to boom the logs to Cross Lake.

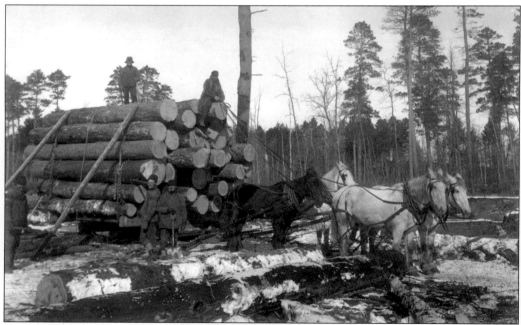

Lumberjacks known as top loaders were the highest-paid men in the logging camps, as they were usually older and more experienced in the art of loading logs onto the sleighs. The logs were rolled up the skids (two small logs placed on one side of the sleigh) and rolled into place with a cant hook.

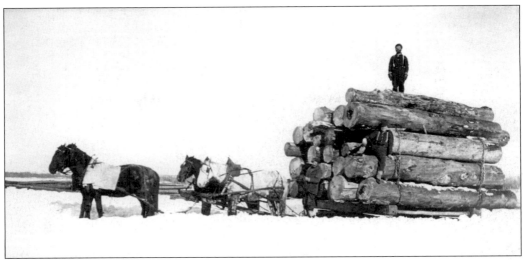

This postcard of Camp No. 1 was mailed on March 12, 1912, and delivered this message, "You can expect me home about the 20th of this month if we have good luck. From Pa." This family man was living at the camp while his family took care of the homestead.

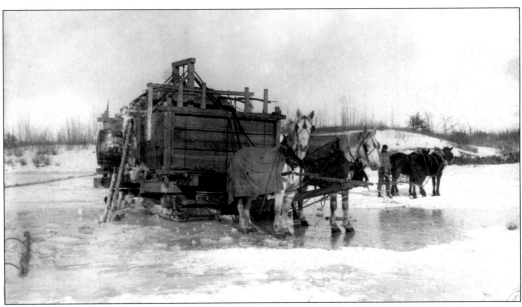

The ice wagon had water tanks that were filled from swamps, creeks, or lakes. These wagons dumped water on the crudely cut roads, and after six weeks of constant hauling, the road was in shape. Once sleighs began hauling logs, the ice wagons worked only during the night.

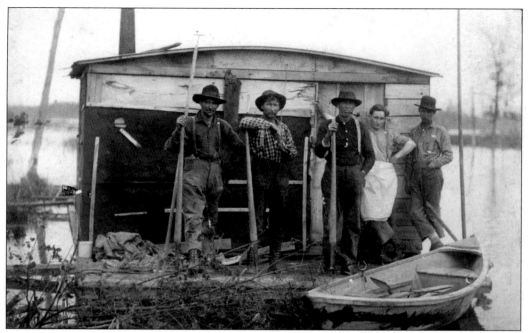

Wanigans were used when booming logs over large lakes and on Mississippi River log drives. With a kitchen and supplies, it served as headquarters and was complete with an office and store where men could purchase dry socks and other clothing and have the cost deducted from their pay. Charles Troxel (second from the left) and the other men are traveling to the Leech Lake Lumber Company at Walker.

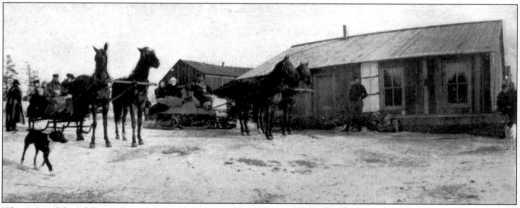

The Northland Pine Lumber Company razed all buildings at its old camp at Cross Lake and moved to new headquarters near Bear Island of Leech Lake in 1905. By 1907, Northland Pine Company operated many logging camps on Leech Lake. The company had a total of seven camps and had work for 1,200 men.

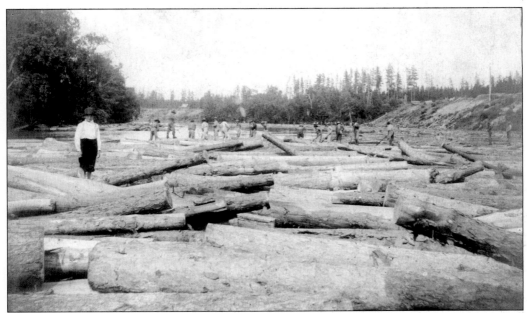

Logging around the tributaries of the Mississippi and Crow Wing Rivers began in about 1851. The lumberjacks that worked on the water were referred to as "river pigs" and it was their job to keep the logs moving. A young boy, Artie, shown in a hat and white shirt in the foreground, is observing the men at work.

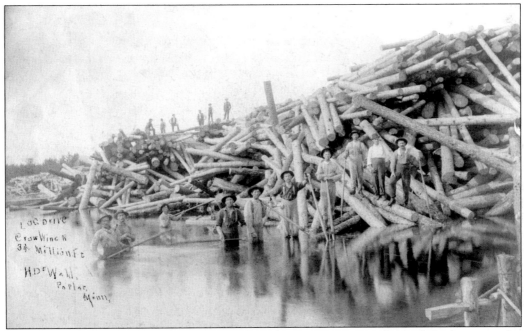

Before railroads came into the area in the 1890s, logging companies dumped the logs onto the ice. When spring came, the logs fell into the river. About 3.5 million board feet of logs had been dumped and were ready to drive down the Crow Wing River. Henry DeWald of Poplar photographed this event.

Logging camps were a man's domain and the cooks were usually men. Occasionally women were employed at the better camps to bake bread and rolls each day as well as pies made from dried fruit, doughnuts, drop cakes, light and dark cakes, and biscuits that provided that touch of home for the lumberjacks.

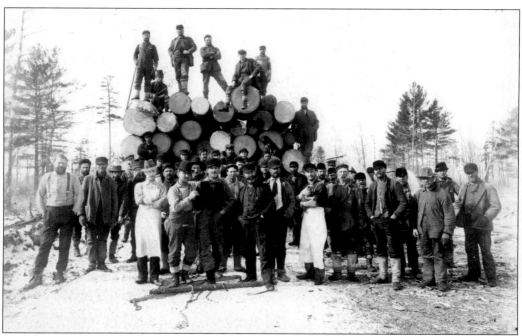

These lumberjacks took time out for lunch and a photograph. Most camps employed about 100 men and one good cook. Lunch in the late 1800s was pea soup, sowbelly (pickled salt pork), beans, and dried fruit. Breakfast consisted of flapjacks and syrup. Most camps fed about 100 men at each meal. No talking was allowed, and it took them an average of 12 minutes to eat their meal.

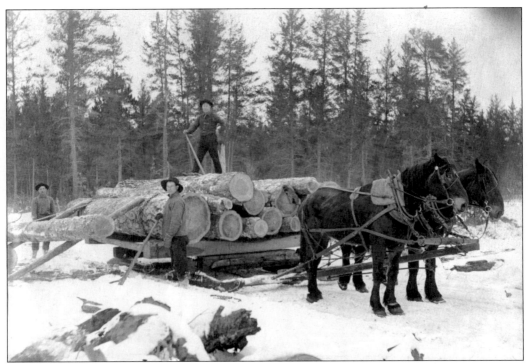

The men on the ground were referred to as the "sender-uppers," with this title later being changed to "hookers." They worked with the cross-haul teamster who was also part of the loading team. As many as 50 logs could be loaded on a sleigh for the trip to the riverbank.

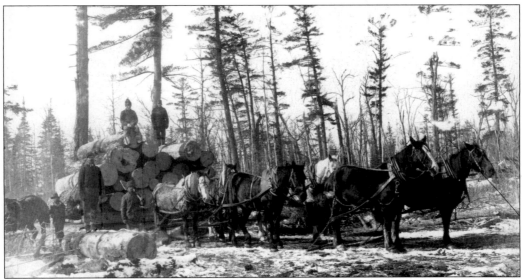

One could always tell the members of the loading crews by the clothing they wore, including topless lumbermen's rubber boots; short, form-fitting jackets; and short, stagged pants. Clothing was woolen and lightweight so the men could move quickly. They kept warm by working. At the end of the day, their clothing was very damp and was hung up in the bunkhouse to dry overnight.

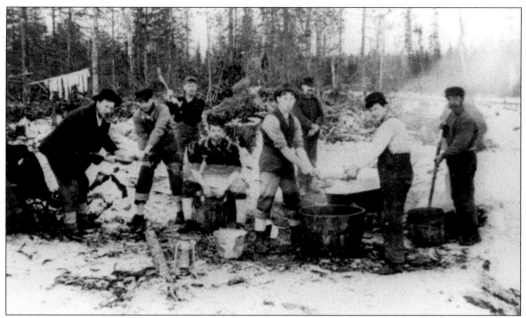

Lumberjacks lived in close quarters in the bunkhouses. Large cast-iron kettles were set up over hot fires to boil water for washing clothes and bedding to kill the head lice. Wet laundry was hung up to freeze-dry on ropes that were strung all over the camp. This was a regular Sunday chore that a lot of the lumberjacks enjoyed.

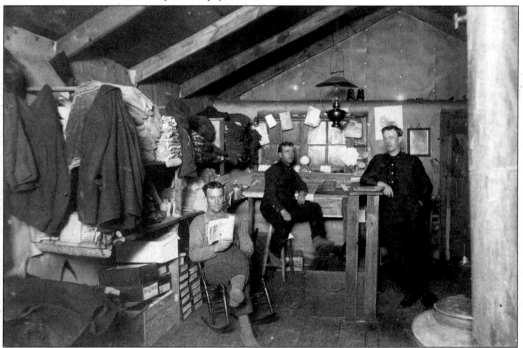

Each lumberjack was given his share of tobacco and snuff each day by the camp clerk. Mitts, socks, clothing, and personal items were also sold here. These were passed out through the window located above the counter. The clerk kept all time records and each man's credits and debits, ordered supplies, and had medicines on hand as he was also the official first-aid man.

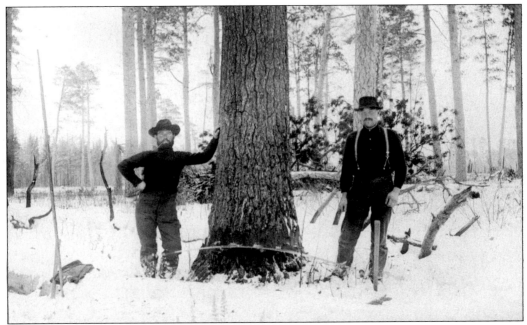

Sawyers worked in two-man teams and used six-to-seven-foot saws. Each day, saw filers passed out freshly sharpened saws and a whiskey bottle filled with kerosene that was carried in a back pocket. A notched cork allowed sawyers to sprinkle kerosene on the saw every time the saw entered a cut. Kerosene cut pitch from the Norway pine and prevented the saw from getting stuck.

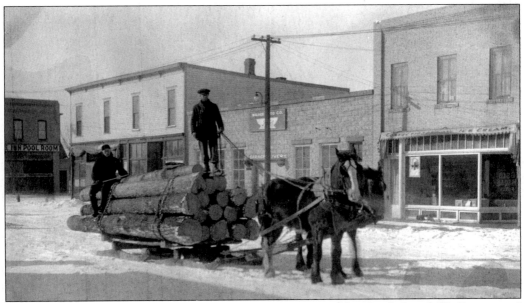

A load of logs passes in front of the College Inn poolroom, Mohler Hotel, Grindall's Garage, and the Fair Grocery at Minnesota Avenue and Sixth Street at Walker. The College Inn put in the boulevard, trees, and sidewalk at their own expense in 1909 and 1911. The Mohler Hotel was built in 1913, and the grocery was added in 1914. Fred Grindall's Ford garage was built in 1915.

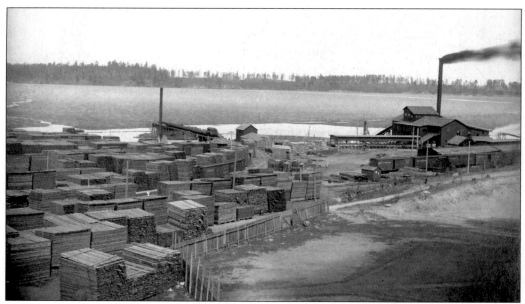

B. F. Nelson, John B. Meagher, Charles Kinkele (Walker mayor and businessman), and Ed I. P. Staede (owner of the First National Bank of Walker) drew up incorporation papers for the Leech Lake Lumber Company in July 1906. Six years of cut logs awaited the saws at the mill that ran 24 hours a day, seven days a week until about 1915.

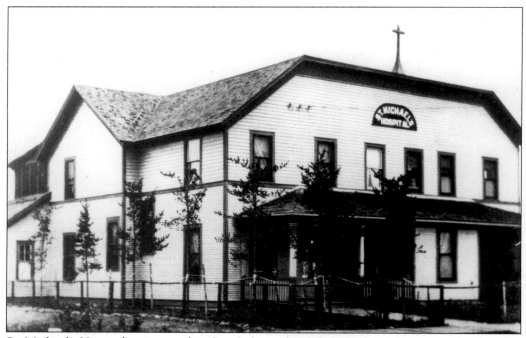

St. Michael's Hospital was opened in Cass Lake in the early 1890s by the Sisters of St. Benedict of Duluth. Sister Amata, the lumberjack sister, snowshoed to camps and sold hospital insurance tickets from $1 to $5 each. The lumberjack was insured free care for a year. At night, she darned socks and listened to lonesome talk of families or baked pies.

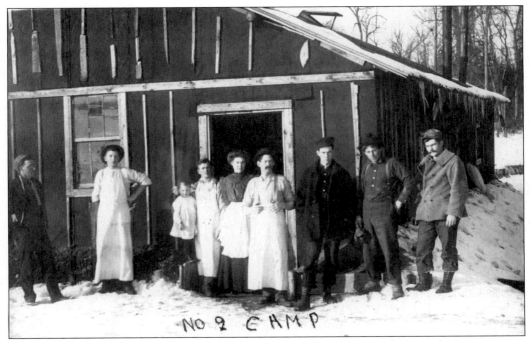

Camp No. 9 was kept well fed by the cook and his family members who were his assistants in 1905. The assistants peeled potatoes, waited on tables, washed dishes, swept and mopped floors, and tended the lamps. This camp must have had many lumberjacks and was desperate for a good cook as they allowed the cook's family to stay in camp with him.

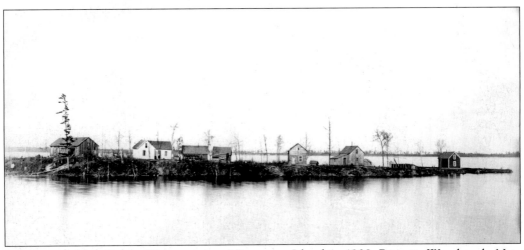

Bill Rogers's logging operations were on Minnesota Island in 1908. Born in Woodstock, New Brunswick, in 1848, he worked in Minnesota lumber camps in the late 1860s. Three hundred lumberjacks worked in the Minnesota Island and Leech Lake siding camps. He operated four camps in Boy River country and became the first man to complete a log drive out of the Boy River in one season.

This National Recovery Administration (NRA) camp was established at Pine Point near Onigum on the Leech Lake Reservation in January 1934. About 60 local men developed a campground, eliminated undesirable timber, and built four miles of road. Dick Reider, later of Ponto Lake Township, was one of three cooks. Sheriff C. E. Merry's brother was another cook, and Jake Plankers of Walker was bull cook.

A group of Civilian Conservation Corps (CCC) recruits must have had KP duty, a job that was disliked by most, and decided to make the best of it by clowning around for a photograph in between their designated duties. They were allowed a little slack in military decorum as they were just boys.

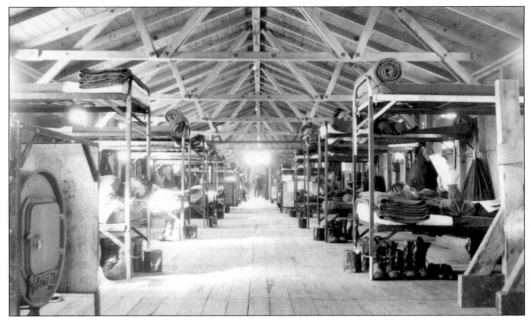

This bunkhouse at Camp No. 1723 was located at Breezy Point on Leech Lake near Walker in 1935. It was large enough to house about 200 men, who were to work in the forest thinning out brush and gooseberry bushes and planting new seedlings, building roads, and fighting fires. The CCC camp was operated by the U.S. Army and adhered to military regulations.

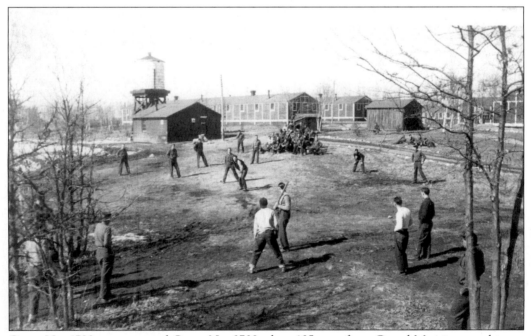

Camp No. 1723 was renamed Camp No. 3709 when 135 men from Grand Marais moved in on July 16, 1939. One of their jobs was to maintain a toboggan slide and ski slope in the Shingobee Hills Playground area as well as to plant seedling pine trees. Weekends were free and the boys soon were able to get a baseball game going, even in the early spring.

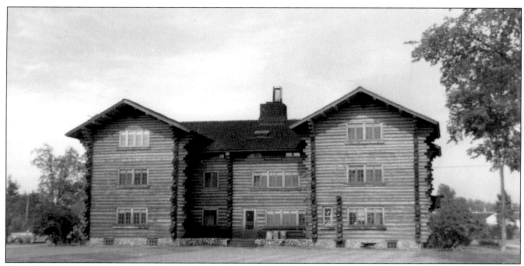

The forest boundaries were established by Pres. Theodore Roosevelt on June 27, 1902. On May 23, 1908, this area was named the Minnesota National Forest. It was renamed the Chippewa National Forest on May 22, 1928, to honor the Chippewa Indians living nearby and within its boundaries. Due to a shortage of funds and manpower, fire prevention was the only work carried on between then and 1933. A headquarters building was constructed in Cass Lake in 1935 by CCC boys and Works Progress Administration (WPA) men from native red pine logs fashioned after the old Scandinavian art of chinkless log construction. The building was added to the National Register of Historic Places on January 31, 1976. The U.S. Forest Service still uses the building as their headquarters. The second photograph shows a well-stocked supply shed with all the tools and equipment neatly stored.

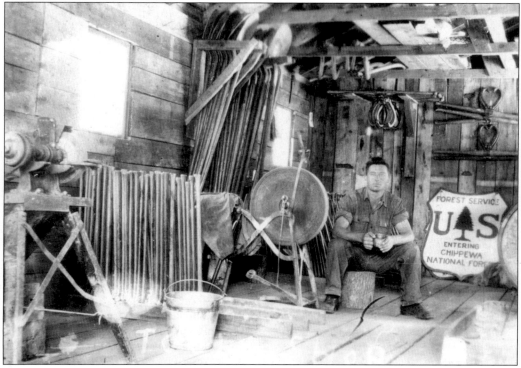

Three

EARLY SETTLERS AND HOME PLACES

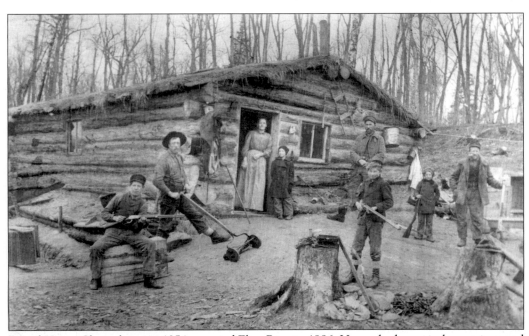

David Henry Slater, born in 1854, married Eliza Rice in 1886. He worked as a timber cruiser, and while working, he established his homestead, North Star farm, where he also operated a sawmill to furnish lumber for logging camps and the Soo Line Railroad. Slater Township was named in his honor. Those at the Slater homestead in 1905 are Charlie Slater, John Anderson, mother, Lucille, George, Dewey, David, and Harry Slater.

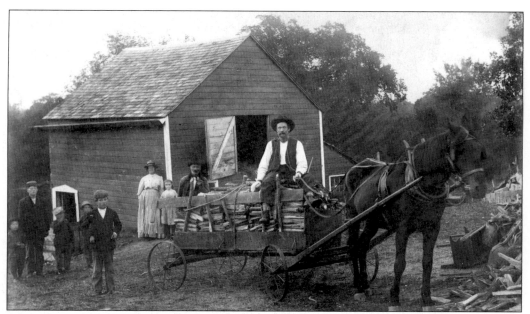

John Alexander Gilmore took up a homestead in Cass County near the village of Pine River in 1909. He and his wife, Ida Clark, conducted a hotel in Jenkins in 1919. They had eight surviving children in 1926. Gilmore died of a heart attack while hunting deer in the woods that he dearly loved.

John Hopen Sr. was born in Norway and came to Walker in 1909 to file on a homestead in Turtle Lake Township. He married Louise Larson in 1910. They had 10 children. Here Hopen and his bull bring home a load of shingles from the neighbor for his new roof. He was an accomplished stonemason and worked at this trade until he was 75 years old.

Millie Chase Allen lived at Gull River where her father, B. F. Allen, was a merchant. Reverend Beard performed the second marriage in Cass County when he married Millie and Joseph B. Cunningham, a Civil War veteran, on August 17, 1881. Built by the Gull River Lumber Company, this was home to the Cunninghams. After Joseph's death in 1922, Millie lived here with her son Earl.

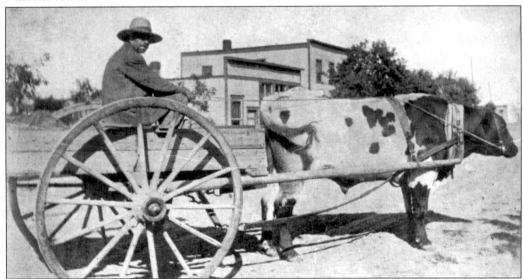

John Ecke came to America at age 28 from Sweden and arrived in Walker in 1895. In 1900, he bought a farm three miles west of Walker and lived there 36 years. A farmer and a lumberjack, he helped build the railroad from Brainerd to Walker, the Cass County Courthouse, and Ah-Gwah-Ching. His wagon was frequently seen in Walker. Judge Eli Wright's store, 1896–1916, is shown in the background.

Charles F. Campbell was born in New Hampshire about 1856 and raised at Anoka, Minnesota. A blacksmith by trade, he worked with Josh Drumbeater on the original Leech Lake dam in 1882. In 1896, he married Mary White, or Tay-cum-ege-shig-eke, meaning "one woman," daughter of Waubojeeg III. Their son Charles Wallace was born at Sugar Point in the sugar bush on April 29, 1898. In 1900, Campbell moved to an area across the Leech River from Paul Buffalo. In 1907, he moved to Federal Dam and built his blacksmith shop along the Leech River while he worked as blacksmith for the government dam. In 1918, his residence was located on the south edge of the campground that was leased from the corps of engineers. His son Charles Wallace attended Leech Lake Indian Boarding School and the Flandreau Indian School, where he studied carpentry. Mary lived until 1970, and Charles Wallace was 94 years old with many descendants at the time that he died in 1992.

William Chester (Chet) Fleisher came to Hackensack in the early 1900s and built a sawmill at the town dock on Birch Lake and later a blacksmith shop. Son Jacob Adelbert (Jake) Fleisher worked at both businesses, and as a teenager, he worked as a fishing guide. He operated Jake's Garage and later built a new building, repaired outboard motors, and drove the Hiram Township school bus for 19 years.

Many settlers arrived at their Cass County homesteads late in the summer when cold weather was just around the corner. Out of necessity, settlers built shelters with whatever the forest had to offer. Often these were poplar trees, which insured that the structure would be a temporary residence.

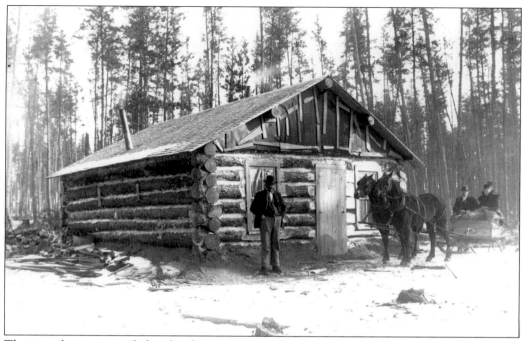

These settlers were settled in by the time snow fell. Their wood was split and ready to use to heat the home. Travel was difficult, as early roads were mere trails through the forests. The best method of travel was by horse and sleigh during the long, cold winter months.

Thomas Welch, a Cass County pioneer, walked through Cass County scaling timber for a logging outfit long before the railroads came in. He put up a sawmill on Leech Lake and lived in this house in Turtle Lake Township from 1931 to 1936. A local family maintained the building as a family retreat for many years.

Four

TOWNS, PAST
AND PRESENT

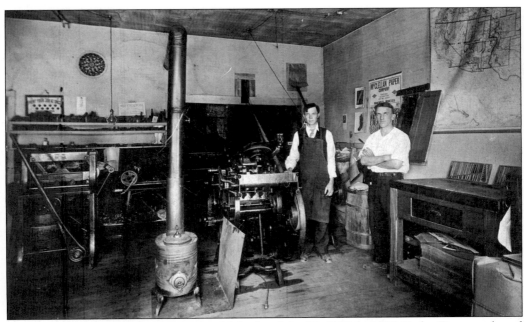

The first issue of the *Walker Pilot* was published on May 26, 1897. In 1905, Farley Dare purchased the *Walker Pilot*. In October 1916, Harry W. Bright (right) leased the newspaper from Dare while Dare was a representative to the state legislature. When Dare died in August 1917, Bright continued as editor. Roscoe Croff (left) assists in this 1917 photograph.

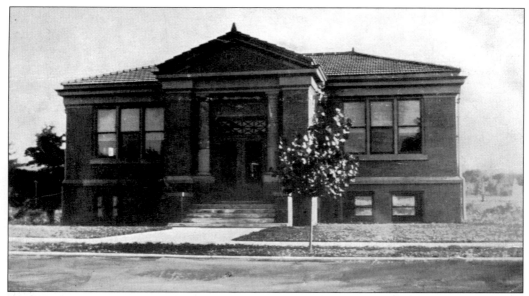

In 1907, Emma Spencer appealed to the Andrew Carnegie Foundation for a $9,000 grant. On April 15, 1910, the Carnegie foundation donated $6,500 for a public library. The village pledged support and instituted a tax levy. Dan DeLury donated the land and Walker became the smallest town in the country with a Carnegie library. On March 31, 1976, the library was lost to fire.

William F. Wilson is standing in front of the steel jail cells in Remer. Wilson was elected as constable in the 1914 election, and he served until 1917. In 1912, the village council decided it was time to fit up the jail with bedding. The jail cells were sold to Federal Dam in 1925 after they had been unused at Remer for several years.

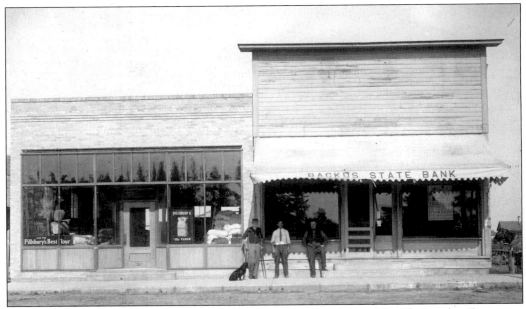

The village was named for E. W. Backus, part owner of the Backus and Brooks Lumber Company. The Backus State Bank was built in 1907 and opened for business in August. Directors were Ed I. P. Staede and J. S. Scribner of Walker, J. W. Bailey and A. O. Miller of Backus, and Peter Denis of Hackensack. Officers were Staede, president; Bailey, vice president; and Miller, cashier.

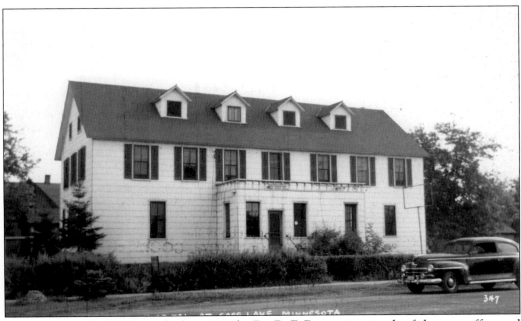

The Cass Lake Hospital was built in 1914 by Dr. D. F. Dumas just north of the post office and south of the *Cass Lake Times* office. The ground floor was occupied by L. H. Burns's drugstore while the upper rooms were used for the hospital. In 1955, Louis Stirwalt opened a boardinghouse at this location.

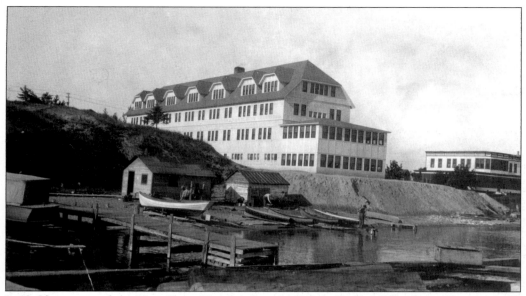

L. H. Chase opened the New Chase Hotel on June 8, 1922, in Walker. There were 62 rooms with hot- and cold-running water, and many had baths. It was reputed to be one of the finest eating establishments in Minnesota and catered to tourists in the new age of automobile transportation. The building was entered on the National Register of Historic Places on June 4, 1980.

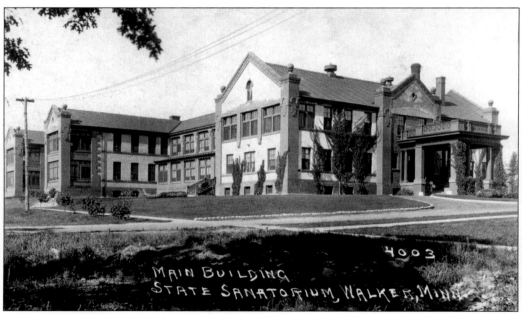

The Minnesota Sanatorium for Consumptives was opened near Walker in 1907 and was the first state-operated facility. The name changed in 1921 to Ah-Gwah-Ching, an Ojibwe word that means "out-of-doors." Tuberculosis patients were state residents and had the best medical care and home-grown food. They spent periods of time covered in blankets on open-air porches. Ah-Gwah-Ching was added to the National Register of Historic Places on July 25, 2001.

This postcard was mailed from Pine River on January 21, 1910. "My dear Cousin . . . Hope you had as pleasant a time at Christmas as I had. I just had a lovely time. I am getting along fine with my school except that two of my best pupils have gone away and I miss them terribly. It has been quite cold awhile but now we are having fine weather. Your loving cousin, Kristine."

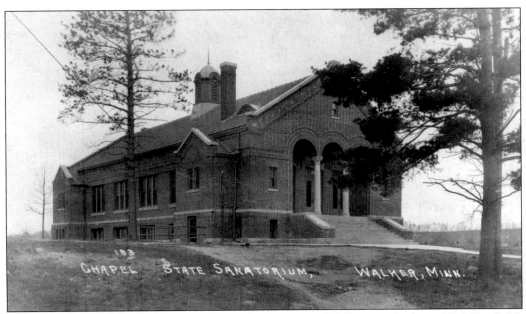

The recreation hall and chapel at Ah-Gwah-Ching near Walker was built in 1915. Dr. P. M. Hall, acting superintendent in 1918, encouraged staff to plan entertainment for patients that included parties, dances, and play productions. Patients and staff became the entertainers. This building also served as a chapel with religious services for patients. The building was demolished in 1957, and the bricks were used for a maintenance shop.

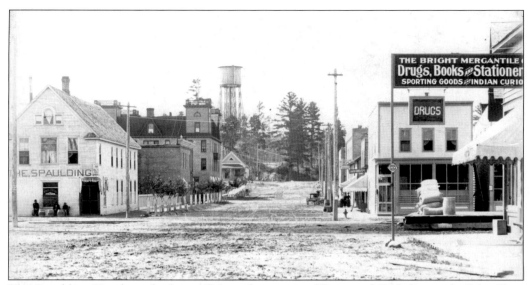

The Spaulding Hotel was built in 1896 on the corner of Front and Fifth Streets by John King and was one of the first hotels to be built in Walker. This building was also home to the Corner Saloon. A fire destroyed the building before 1900. Dave Brassard's Café was here in 1922.

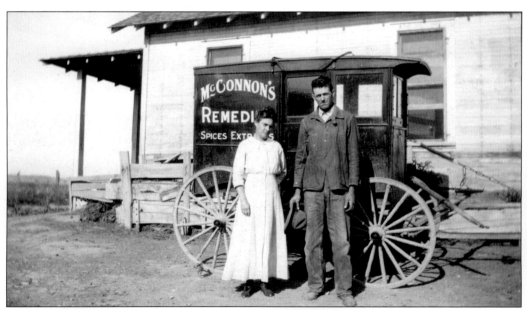

Many Cass County settlers were visited by peddlers. Peddlers were a favorite sight, as they traveled and supplied householders with remedies, flavoring, extracts, spices, and toilet articles. McConnon and Company was established about 1889 in Winona and was the early competitor to Watkins products that were also produced in Winona.

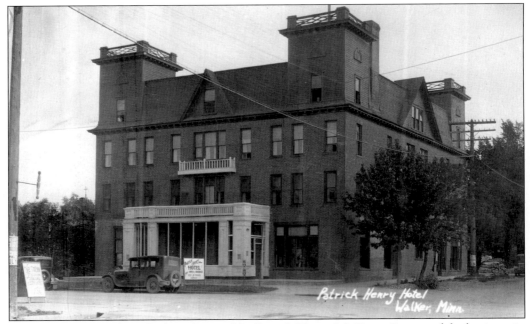

Patrick Henry Hotel was built and owned by Patrick Henry McGarry. It opened for business in Walker on September 17, 1897. This was the center of activity for the early village of Walker. Physicians and dentists set up offices, church services were held there, salesmen set up their wares in sample rooms, organizations held their meetings, and members perhaps imbibed a bit at the bar located there also.

Pine River's history began when George Angus Barclay purchased 840 acres along the river, and Dennis McNannie, an Ojibwe, settled on 80 acres in Barclay Township. Together these two men opened a trading post on the Pine River in 1873. By 1894, plans for building hotels, stores, saloons, and schools were underway. J. G. Dawes platted the village in 1898 and Pine River incorporated on December 5, 1901.

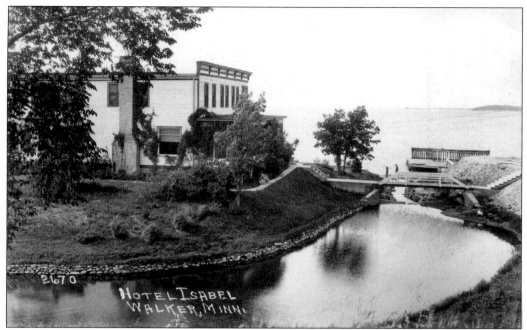

The Isabella Hotel was built by Burt Chase in 1915 near Lake May Creek in Walker. It continued as a formal dining room and annex to the New Chase Hotel that opened in 1922. The Marie Peterson family owned it in 1950. The name changed to the Northwoods Beach Motel when it was sold in 1980. Units were sold to individual owners.

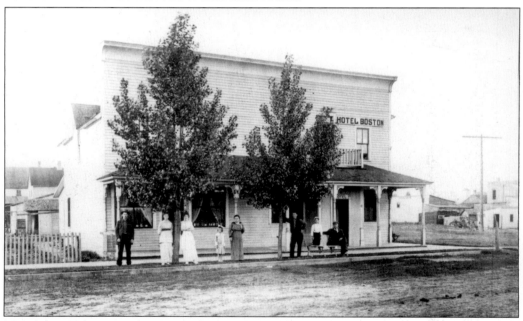

Mrs. Adam Kohn arrived in Cass Lake in 1906, and by 1907, she was the landlady of the Boston Hotel. She operated the hotel for 27 years before turning it over to her daughter and son-in-law Raymond Larson. Located uptown in the village, it was complete with a sample room, bar, and eating room. She played an important part in the business, social, religious, and charitable life of the community.

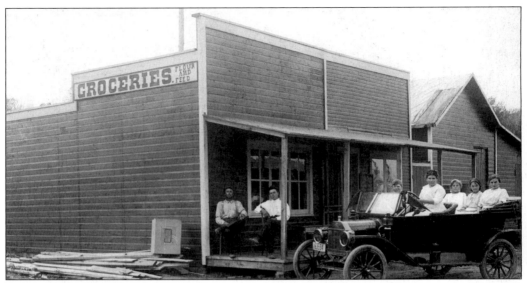

David Clabaugh and Charles Fletcher sit on the porch of Clabaugh's store in the Clabaugh addition of Remer. Clabaugh owned a mercantile store on lot 14 of block one. He sold to Henry Wittwer on May 20, 1918. Clabaugh was appointed to the Remer Village Council in 1912 and was awarded the contract to build the Remer Village Hall in 1912.

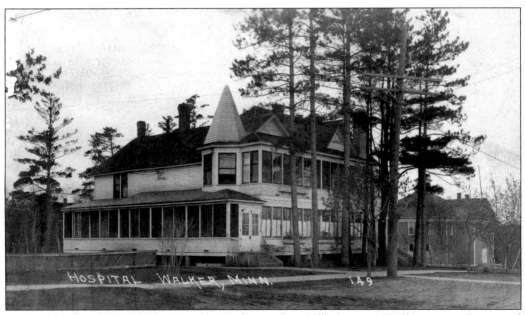

On October 30, 1903, P. H. McGarry built a hospital on Fifth Street in Walker to care for injured lumberjacks. Dr. Frank Leslie Wilcox was the physician. He passed away at the hospital in the late summer of 1931. After Wilcox's death, Dr. Otto Ringle took over operations until 1934, when he built a new hospital on the east side of Fifth Street.

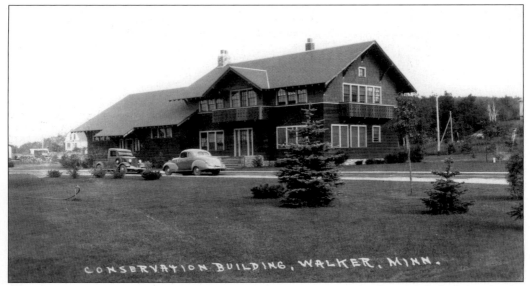

CONSERVATION BUILDING, WALKER, MINN.

The conservation building was built in 1934. Depression-era workers provided the labor for the building and the construction of the Walker Wildlife and Indian Arts Museum. In the 1940s, the WPA set up a gift shop with items made by the people of the Leech Lake Reservation. On January 15, 2003, the building was entered on the National Register of Historic Places.

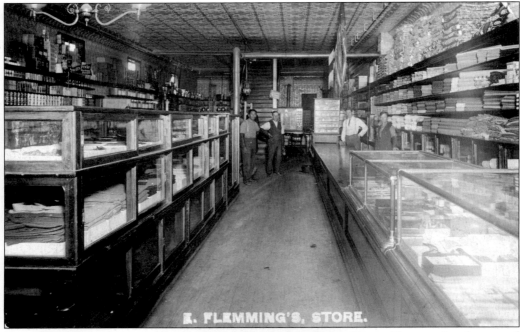

E. FLEMMING'S. STORE.

Ernest Flemming was one of the founding fathers of the village of Bena. He owned and operated the Flemming store, which he lost to fire in February 1906. Shortly after the fire, he built a large general store on the same site. He lost this store to fire in September 1913. He rebuilt for the third time and operated the store until 1937.

The first post office in Walker was located in the Gardner Drug Store with J. G. McGarry appointed postmaster on February 29, 1898. The post office moved to the corner of Fifth Street and Minnesota Avenue in Walker by 1921. Early postmasters were Thomas J. Nary, Arthur McBride, George E. Crow, and George A. Phelps. This photograph is dated July 19, 1917.

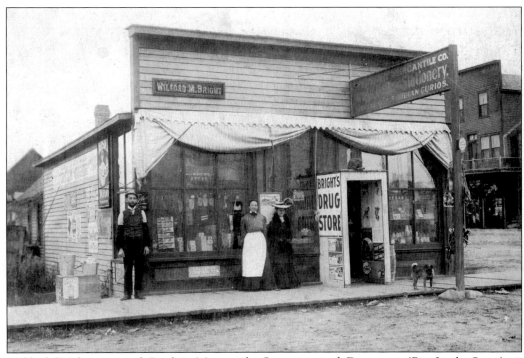

Wilford Bright operated Bright's Mercantile Company and Drugstore (Big Little Store) in the former Croff building in 1900 in Walker. Bright retired in 1912 and sold the business. J. B. Spencer arrived in Walker in 1896 and built the Spencer Hotel (right). W. P. Mohler took over management in 1909 and changed the name to the Mohler Hotel.

Walker's first drayman, Joe Lane, owned the Dray and Livery and City Dray Line. John Sempf bought him out. His dray team pulled the fire-hose cart for the Walker Volunteer Fire Department. Ed Wright is the driver in the photograph. John Sempf was a pioneer citizen of Walker. Besides the dray service, he owned a saloon. John Snyder worked for him in the livery barn in 1910. When Sempf died on May 12, 1913, the funeral services were conducted by the Red Men's Lodge. The entire village mourned his passing and every business in town closed its doors as a token of honor to the man who was highly respected and well liked. N. W. Olson and I. P. Byhre became owners in 1914. It became the Griffith Blacksmith Shop and Dray Line in the 1920s with Emil Bilben as their employee.

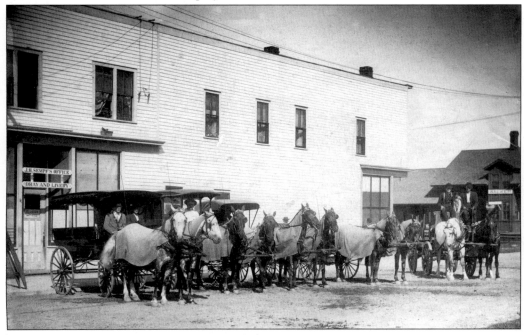

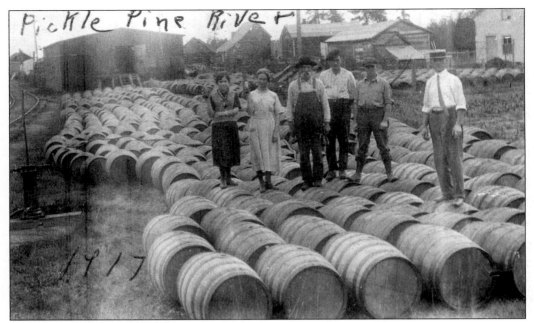

In the period between the two world wars, pickles were a major agricultural product in the Pine River area and the big name in pickles was Wefelmeyer. This 1917 photograph shows dill pickle barrels being sun cured outside the Wefelmeyer plant in Pine River. Liquor barrels were used. Fred Wefelmeyer is shown wearing the hat and tie in the front.

The first and only hanging in Cass County took place on August 30, 1904, at Walker. William and Dora Chounard owned a house of ill-repute at Cass Lake. Chounard was jealous of the attentions shown his wife and fired three shots into her body. Dora begged for leniency for William before she died. Chounard was arrested and convicted of murder in the first degree.

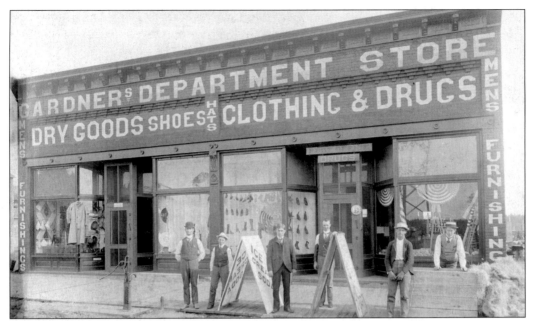

John T. Gardner settled in Walker in 1895, built the first brick building in Walker, and occupied it with a drugstore and a bank. In 1899, he moved to Cass Lake, where he built the building shown in this photograph and founded a business that was continued by his son John T. Gardner Jr. John Sr. was one of the early promoters of the town of Richards in the Chippewa National Forest in 1906.

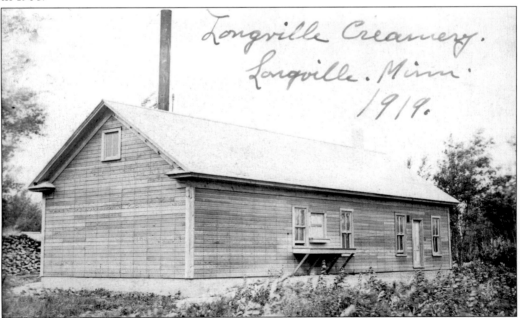

The Longville Co-Operative Creamery Association was organized in November 1916. The creamery was built in 1917 and opened on July 9, 1917. The officers were president Leo Jordan, vice president I. G. Emery, secretary Jake Tabaka, and treasurer Andrew Ford. The new creamery had about 60 farmers that supplied the cream needed to make butter for buttermaker Frank Pace. In 1927, the creamery was certified as a Land O' Lakes creamery.

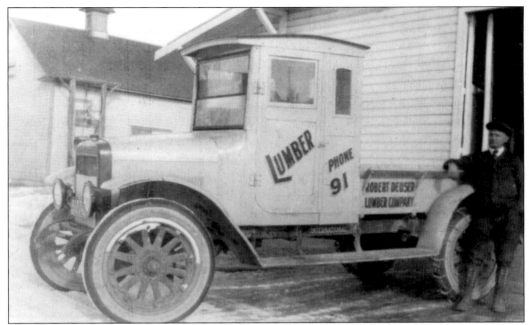

The Robert W. Deuser Lumber Company was founded in the early 1920s at Cass Lake. Before starting his own company, Deuser worked as retail manager for the J. Neils' Lumber Company and eventually bought the Neils' log marks and sawed deadheads from Cass Lake. Deuser died in Bemidji in 1977.

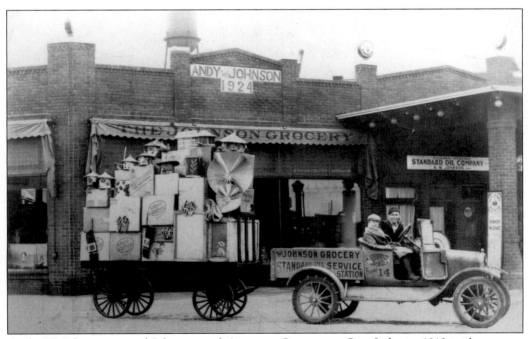

Andy W. Johnson owned Johnson and Auringer Grocery in Cass Lake in 1913 with partner, William Auringer. By 1924, Johnson was the sole owner. His son Ellsworth held a grand opening for Johnson Red and White Store on Second Street in August 1945. Andy Johnson's son Alfred owned the Texaco service station next door.

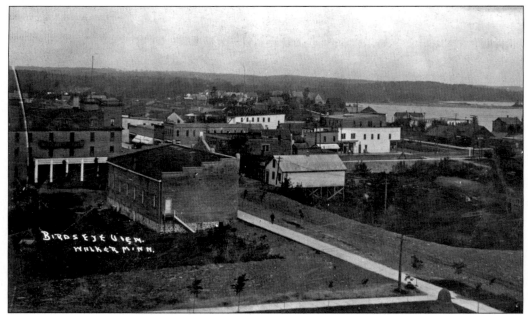

This bird's-eye view shows the Pameda Hotel and the Walker Opera House on the left. These buildings are still in existence on Minnesota Avenue, Walker's main street. P. H. McGarry, Walker's founding father, fought to have the city designated as the county seat. Walker was the name chosen in an effort to entice T. B. Walker to build his sawmill here. The village was incorporated on March 10, 1896.

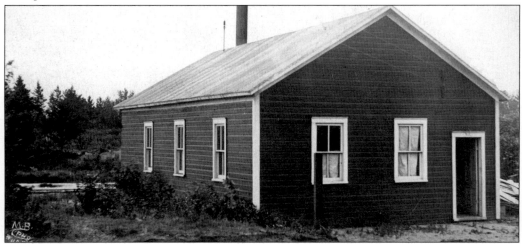

In 1909, dairy farmers incorporated the Pine River Farmers' Cooperative Association as their marketing association. On June 15, 1909, the Pine River Creamery was organized and the first creamery was built. The building was still in use after the new creamery was built in 1913 and was not torn down until 1949. I. N. Ingersoll was the first Pine River buttermaker. The first dairy delivery truck in the Pine River area was owned and operated by Joe McAllister. By 1926, dairying had reached such a level of production that statewide distribution was considered. A regional cooperative creamery association was organized on April 24, 1926, and became affiliated with the Land O' Lakes Creamery Cooperative. They purchased the creamery building from Lauritzon and Kielty. The Pine River Cooperative Creamery was ready for business on October 9, 1926.

Ray and Ella LeMire (left) owned the LeMire Hotel and general store in Federal Dam. They are shown in front of the store with Andrew Lego about 1925. Andrew Lego had a pool hall and card room in one end of the hotel. In 1919, the Hotel LeMire was filled to capacity by fishermen.

The Walker Steam Laundry was opened by R. J. Broughton and M. H. Erickson in the Lakeshore Hotel building in 1928. As well as doing laundry for the hotel, Walker patrons brought various items in to be cleaned. Their business must have been brisk, judging by the number of employees in the photograph.

From Monday to Wednesday, February 20–22, 1922, a howling blizzard hit Cass County. Walker had snow piled up on the streets for several days. School busses were unable to venture out. For the first time since 1896, the Minnesota and International Railroad discontinued all trains. The first train from the south reached Walker on Thursday.

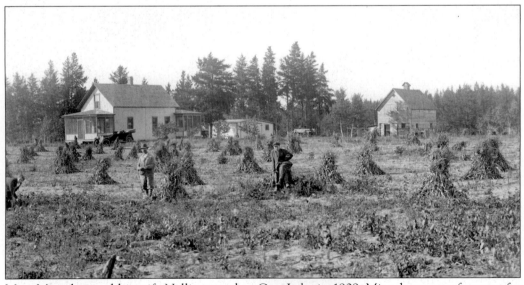

Matt Minzghor and his wife Nellie moved to Cass Lake in 1909. Minzghor was a foreman for the Kenfield Sawmill and later for J. Neils' Lumber Company. He purchased a farm, which was located at the present site of the Palace Casino. After his wife Nellie died, he married Edvina "Honey" Brown in 1925 and had one of the finest Guernsey herds in Minnesota. For over 30 years, he delivered milk seven days a week.

Five

SCHOOLS

The Huset School was located in the area known as the Island in section 11 of Boy Lake Township. Islander John Huset donated an acre of his land for the school in 1912. The school closed in 1937 and the building was moved to the Cass County Museum grounds in 1968. George Engebretson and Oren Forbord, nine-year-old boys, peeled the logs used to build this school.

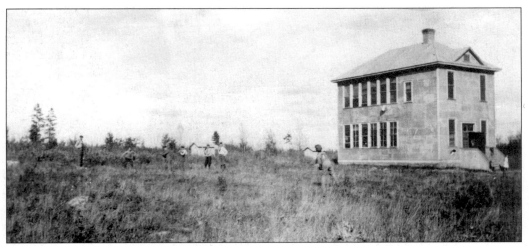

The Boy River School was built in 1912 and used until 1926. It was a two-story building with one large room above the other and no modern conveniences. The community held an Armistice Day dance there in 1923. Each lady was asked to donate a lunch for two, which sold for 50¢. Proceeds went to the school.

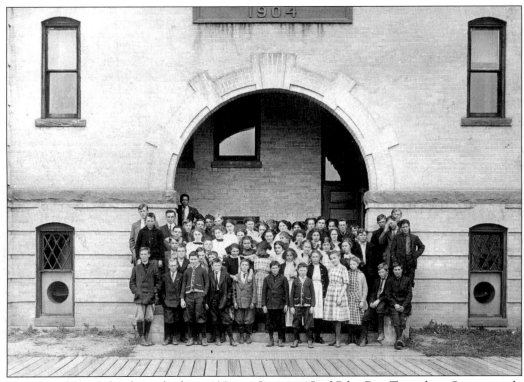

The Cass Lake School was built in 1904 in Section 15 of Pike Bay Township. Some people identified in this 1911 photograph are Harold Lett, Mildred McGinnis, Marie Tapley, Eddie LaGess, Fred Egan, Fred Johnson, Ferd Christianson, Mabel Torail, Ellen Wood, Iris Hough, and Hattie McDowd.

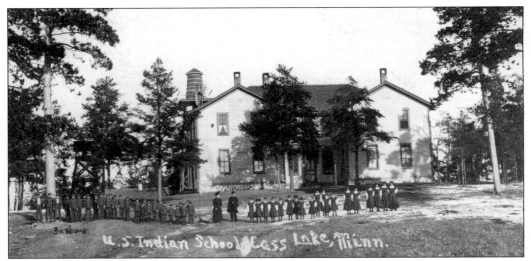

A U.S. Native American boarding school at Cass Lake was one of three schools that the government built on the Leech Lake Reservation. This school remained in operation from the middle 1800s to the 1920s. This postcard was mailed from Cass Lake on June 10, 1910.

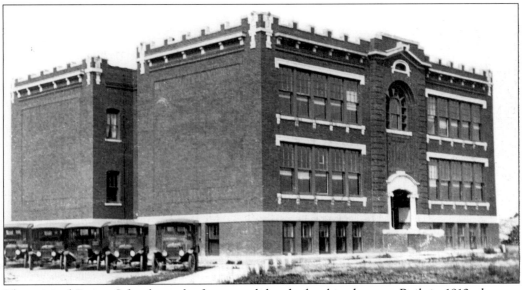

The original Remer School was the first consolidated school in the area. Built in 1912, the new brick school had five rooms each for the younger grades and for the high school. In 1920, the state director of transportation said that the Remer system of school-owned-and-operated busses had proved to be the very best in the state. They held that title for two years with Harry Schultz as transportation manager and mechanic.

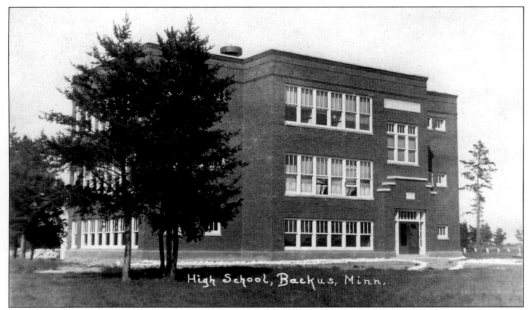

High School, Backus, Minn.

Backus High School was completed in March 1916 after outgrowing two school buildings and losing a third to fire. In 1916, the teachers were W. H. Hayes, Lulu Montgomery, Grace McCallum, Kathleen Hall, Lottie Hudson, and Annie Palmer. Waldo Luebben, son of Jasper Luebben, was the first graduate of Backus High School. A WPA addition was built in 1939.

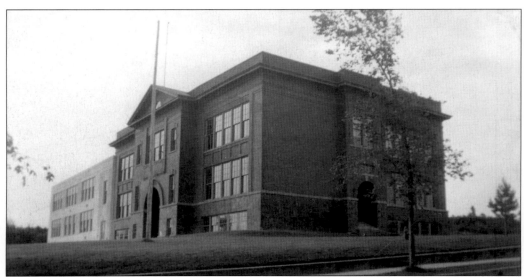

Walker's second school building was built high atop the hill that overlooks the village on schoolhouse hill at the top of Fourth Street in 1908 and 1909. The first graduating class of 1910 consisted of Robert Oliver and Leila and Verne Dally. A high school addition was added as a WPA project in 1938, with an auditorium and gymnasium and several classrooms added in 1940.

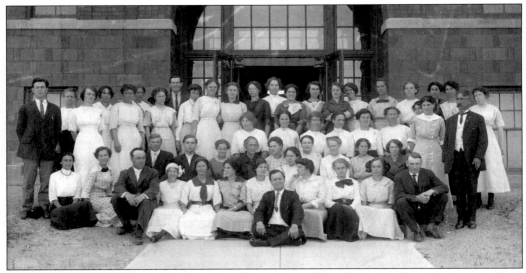

Walker Normal School provided training for teachers. After high school graduation, students spent part of a year learning teaching methods and then went out to country schools to practice. Many students rented rooms at the boardinghouses in the village during both their high school and normal school educations.

Walker's first school bus was driven by Amund Hillberg. He was known to his friends as Herman. He was seven years old when he and his parents immigrated to the United States from Norway. In 1902, he moved to Kabekona Bay on Leech Lake where he lived on his farm until his death on January 21, 1948.

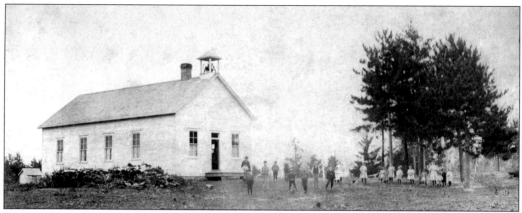

The Hackensack School was built within the original town site of the village of Hackensack in 1899. It had 17 pupils, with Marie F. Lawrence as the teacher. The school was no longer needed when a new school was built 1921 and 1922. Some of those who attended the old school were Bessie Applebee, Orvil Brody, Lucille Duncan, and Mae Fleischer.

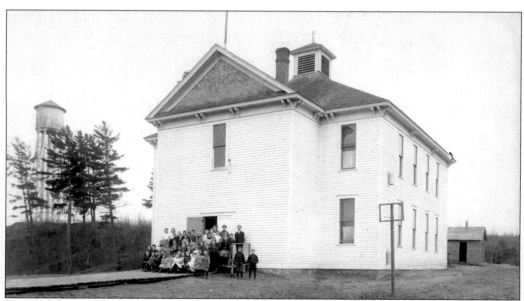

Walker Community School was built in 1898 on Michigan Avenue. Classes were not held until 1899 because the soldiers were quartered here during the winter of 1898 following the Sugar Point battle. Classes resumed and were held here until 1909 when the new building was built. In 1909, J. W. Young was principal. Teachers were Annie Nilson, Alice Mills, Agnes Kinkele, Louise Griffith, and Helen Fluke.

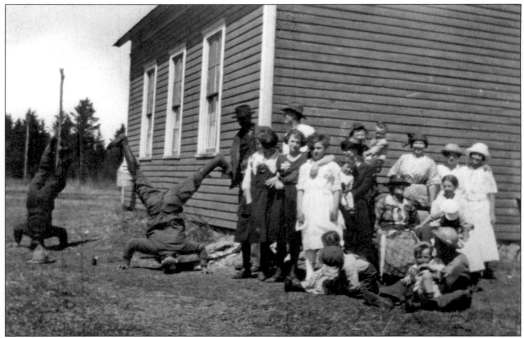

The Moose Hill School was located in Section 34 of McKinley Township. Those petitioning for a school were C. Merritt Southwick, Sam Harrison, Charles Lewis, Henry Harrison, Harry Terrell, E. E. Sager, E. C. Southwick, Peter Anderson, Lavoy Vaughn, I. M. Walker, W. W. Smith, S. S. Whitney, and W. E. Vaughn. This photograph shows children at recess in 1922 or 1923.

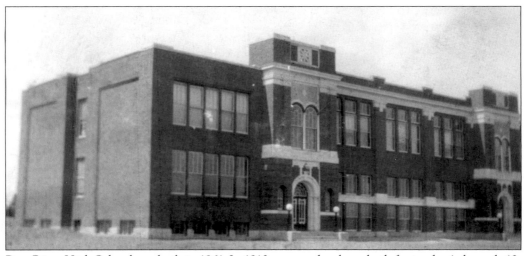

Pine River High School was built in 1961. In 1913, a new school was built for grades 1 through 12. Because of rapid growth, the district struggled and students attended classes in various places, including Mildred and the Pine River Armory. Backus High School and eventually the grade school consolidated with Pine River.

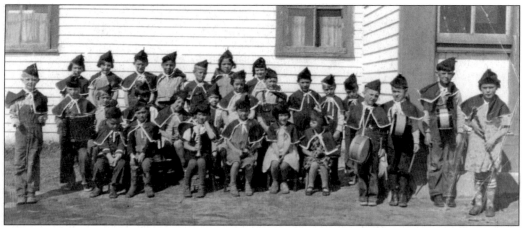

Many students belonged to the Federal Dam School band in 1937. From left to right are (first row) Donald Strom, Leonard Johnson, Cleo Hammerschmidt, Wilma Wolske, unidentified, Patty Miller, George Elison, Larry Lego, Jim Neururer, and Katherine Shoemaker; (second row) Gerald Richmond, Merton Lego, Florence Borchert, Rita Hammerschmidt, Earla Mae Handy, Gloria Chase, Charlene O'Brien, Floyd Borchert, Rodney Struss, Gordon Johnson, and unidentified; (third row) Mary Ann Nistler, Patty Lou O'Brien, Rodney Forsman, Benny White, Lloyd Armbrust, Leona McKeig, and Joanne Ekberg.

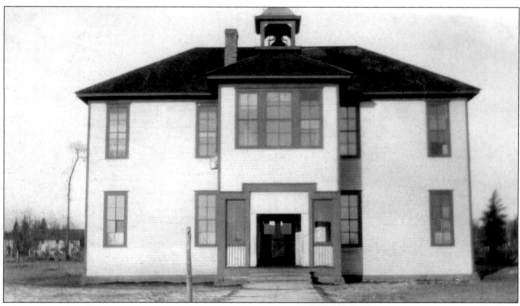

The new schoolhouse at Federal Dam in 1912 was a frame building with two rooms downstairs, two rooms upstairs, and a wide staircase. Four teachers were there in 1914. Mabel Hampl, Catherine Swanberg, Marcella Munson, Elizabeth Showalter, Louise Poore, and Doug Sautbine all taught in this building. It was closed in 1938 when a new WPA school building replaced it.

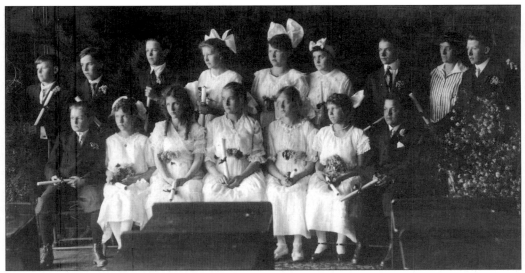

Attending eighth-grade graduation ceremonies at Walker in 1916 are, from left to right, (first row) H. Kulander, Helen Crow, Dorothy Dare, June Thompson, Alice Steadland, Amy Hawkinson, and Bill Rau. The second row includes Catherine McCabe, Lucille Kennedy, and Earl McDougall. Students studied all year preparing for the state board examination. If they passed, they were allowed to continue on to high school.

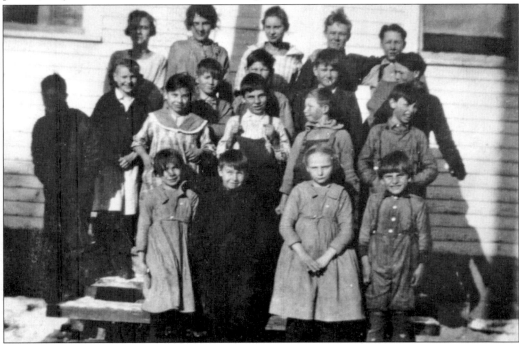

Bungo School in Section 26 of Bungo Township had 13 students in 1897 with Sue Palmer as the teacher. From left to right, these 1920s students are (first row) Margie Graves, Roy Arnold, Zora Graves, and Vernon Knott; (second row) Myrtle Knott, Leonard Knott, Martin Ware, and Walter Graves; (third row) Gerald Seaton, Elsie Knott, Llewellyn Knott, James Ware, Roy Knott, and Clyde Seaton; (fourth row) Julia Arnold, Pearl Holmes, Bessie Abbit, Raymond Arnold, and Richard Ware.

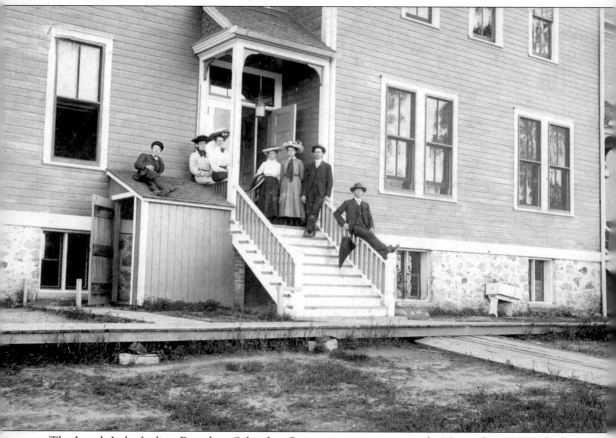

The Leech Lake Indian Boarding School at Onigum was in operation by November 1867. It had the capacity for 60 students. Kraus Kressman was superintendent from 1893 until 1900. William Fairbanks enrolled at the school in 1904 when he was six years old. Dr. L. M. Hardin was the principal and physician then, and John T. Frater was the government agent or superintendent. In 1903, the employees included three males and eight females, five of whom were Native American and six were non–Native American. Emily Peake taught in 1897. Olive Spencer was a teacher in 1902. In this 1917 photograph, the teachers are lounging on the steps after a long day. Charles Chatfield worked at the school as a laborer in 1918. P. A. Starr and Cloie Starr taught there in 1921. The school building was lost to fire in 1951.

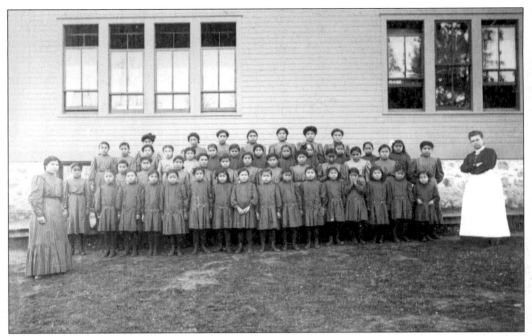

By 1909, the Leech Lake Indian Boarding School had an enrollment of 106. Average attendance was 85. Joseph Soldier attended school at Old Agency and became an esteemed clerk at the Leech Lake Agency office. Both boys and girls were issued uniforms while attending the school. Most likely these students were getting ready for a visit from a federal government official. The boarding school population was usually balanced so that half of the population was made up of girls. The Native American boys were taught a trade and were also often assigned to the school's farm detail since the school was expected to produce its own food under the supervision of the government farmer. Some correspondence exists from Frank Fisher, the farmer in charge at Leech Lake, and some notes exist in a diary from John R. Cummins, who was employed as a carpenter at the Leech Lake Agency from 1865 to 1867.

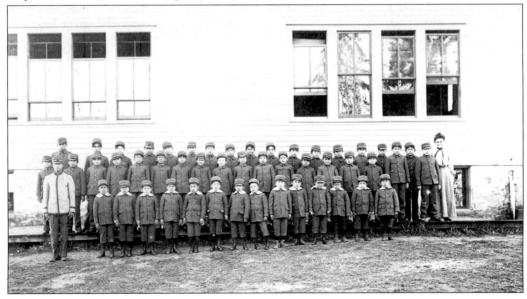

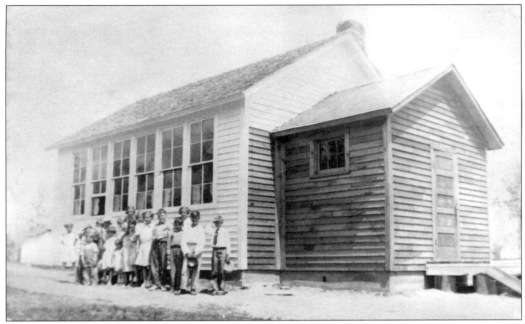

Mary E. Anderson homesteaded in McKinley Township in 1905 and became the postmistress of Wicklow, the smallest post office in the United States. It served a mere 12 persons from January to October 1909. The Wicklow School may have been built as early as 1902. In 1923, the school was moved by Ed Mitchell to Section 6 on land owned by William and Lillian Aldridge in Bull Moose Township.

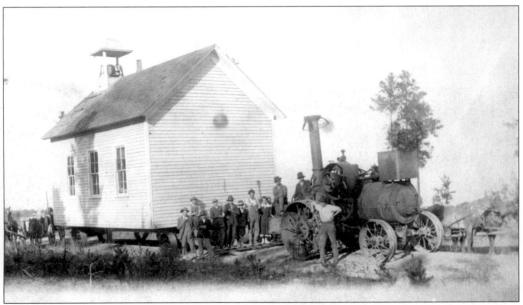

The Tobique School was located in Section 24 of Rogers Township in the early 1900s. Mary Norton taught there in the 1930s. The school closed and the building was sold to Louis Warnert in 1939. Some family surnames in the area were Anderson, Boland, Brum, Carr, Clark, Godfrey, Holts, Jelen, Magoon, Pearson, Peterson, Polosky, Raines, Rogers, Roxin, Spieker, Taylor, and Thomas.

Six

SPECIAL EVENTS

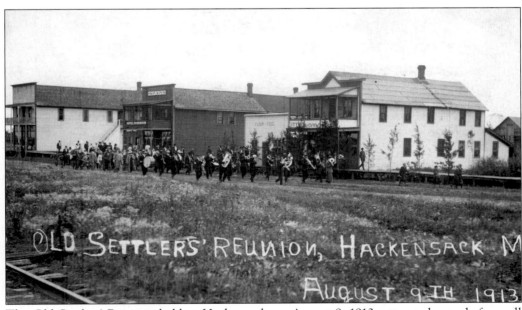

The Old Settlers' Reunion held at Hackensack on August 9, 1913, attracted crowds from all over Cass County. Walker and Backus played baseball resulting in the score of 12–3 in favor of Walker. J. A. Gilberg of Poplar related Cass County history. The Leech Lake band traveled by train to entertain the dancers. Lakeview Hotel, a flour and feed store, and William J. Spain Sr.'s Hotel Endeavor are in the background from right to left.

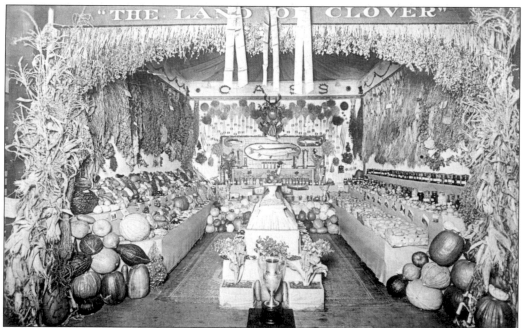

Cass County captured first prize of the northern division of county exhibits at the state fair by leading all counties in alsike and mammoth clover. Jay Brewer of Pine River and Commissioner Fred S. Moulster manned the booth. In 1916, the county received a cash prize of $240 for having the highest score of any county for the second year in a row. Cass County's Fred Grafelman and T. A. Erickson introduced 4-H to Minnesota, and the 4-H building on the state fair campus became the T. A. Erickson building. Cass County took first place again in 1917, with Austin Sarff of Walker and others preparing the exhibit. The county brought home the Loving Cup in 1917 after winning for three consecutive years. The cup has a permanent home at the Cass County Museum.

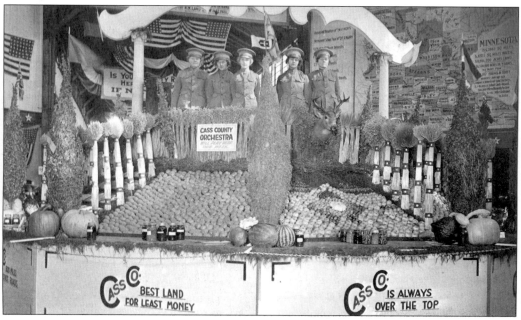

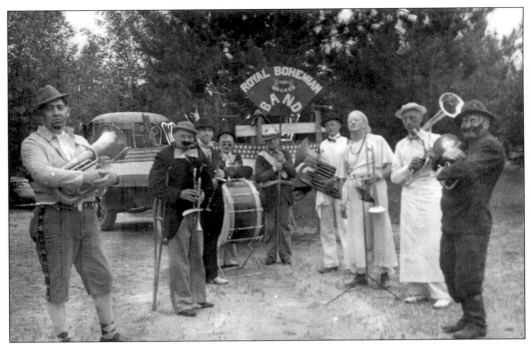

The Royal Bohemian Band of 1942 was composed of members Dr. Otto Ringle, Larry Mengis, Henry Renner, Roy Woodford, Lynn McPherson, Paul Steffenson, Kelley Peterson, and Carl Steadland. Organized by Ringle, they were a popular item at Walker weddings and other affairs. The band even played at a few wakes.

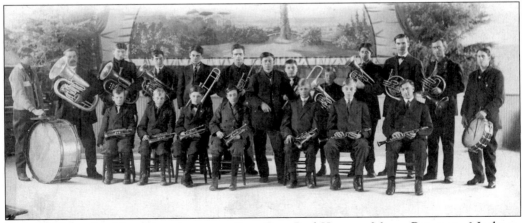

Early Walker school band members were Sam Guy, Paul Krueger, Merns Bateman, ? Jackson, Carl Steadland, Harold Davis, Dick Crow, John Gosney, Leslie Bromley, Herman Rau, Walter Olson, Oscar Oleson, Robert Steadland, Clarence Jackson, Emil Bilben, Ivan Peterson, and Roscoe Croff. This photograph was taken in front of the stage curtain in the auditorium of the Walker Public School.

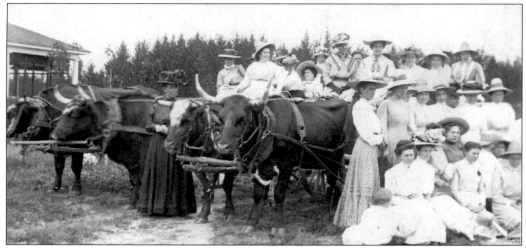

A women's organization, the Leans and the Fats, was traveling to Sand Lake near Pine River for an outing. Seated from left to right are (first row) Mrs. Wideman, Mrs. Silk, Mrs. Dawes, Mrs. Hill, Mrs. Christian, Mrs. Linden, Mrs. Amy, and Mrs. Fox; (second row) Mrs. Curtis, Mrs. Moulster, Mrs. Anderson, Mrs. Barker, Mrs. Whipple, Mrs. Hill, and Mrs. Gilbert; (first wagon) Mrs. LaDu, driver Mrs. Allen, Mrs. Teach, Mrs. Andrews, and Mrs. Kinler between the teams of oxen; (second wagon) driver Mrs. Sherwood, Mrs. Woods, Mrs. Forbes, Emma Holman, Mrs. Westgren, Mrs. Bowman, Mrs. Wagner, and Clara McKissor.

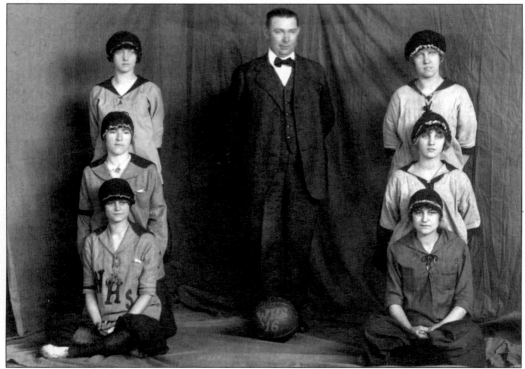

Girls were not encouraged to participate in sports in the early days. Most schools allowed them to play basketball by the early 1900s, as long as they wore uniforms that were befitting young ladies. This was a 1916 all girls basketball team at Walker Public School. The team included Goldie Alexander, Violet McPherson, Beulah Alexander, Elvera Hawkinson, and Emma Rau.

The Walker Home Guard drills at the Walker baseball field in 1917. When Minnesota National Guard units were called away in World War I, the state created the Minnesota Home Guard. The guards had a motor corps battalion with 2,000 private automobiles at its disposal, and they brought supplies to the Cloquet fire victims or transported them away from the fire. When the influenza outbreak occurred, they distributed medical supplies.

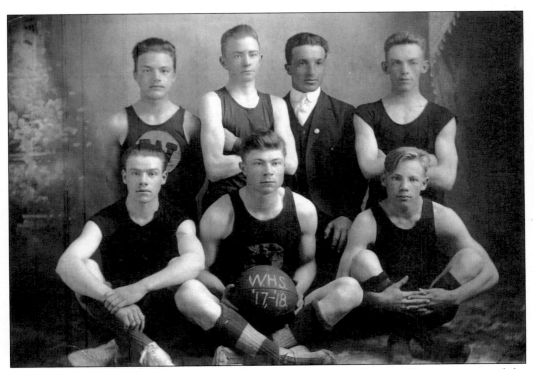

The February 2, 1917, game between Walker and Akeley went down in history as one of the hardest-fought games ever played in Walker. The Akeley team was late for the start of the game because the Great Northern Railway train did not arrive on schedule. The end score was Akeley with 21 points and Walker with 16 points. Players were Earl Rau, Oscar Olson, Roy Greene, Earl McDougall, Leo Goebel, and George Dickerson.

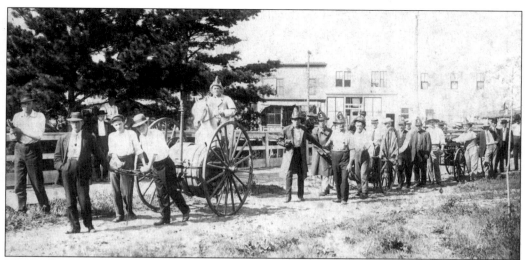

The Walker Volunteer Fire Department was first organized in September 1896 when the village council purchased two dozen pails and built several ladders. The organization was known as the Walker Bucket Brigade. In 1905, the group was reorganized by Chief James Campbell, first assistant H. McCabe, second assistant Robert DeLury, secretary Elmer Sundby, and treasurer Farley Dare. In addition to the officers, there were 10 other members.

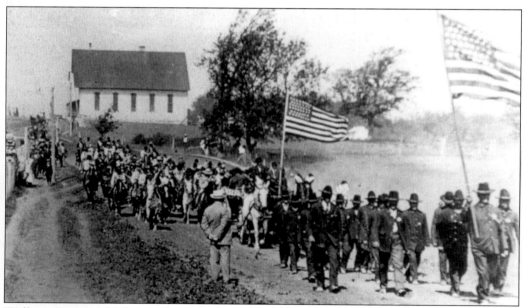

Walker's Fourth of July parade in 1898 included Brainerd and Walker Red Men, the village officers, the White Duck Club, a float, and William Dreskell's marching band. Afternoon aquatic sports were Native American canoe races and log rolling. Various kinds of foot races were run in the late afternoon. A mock naval battle on Leech Lake where the United States captured the Spanish fleet was the evening entertainment. The evening ended with Dreskell playing dance favorites in the bowery.

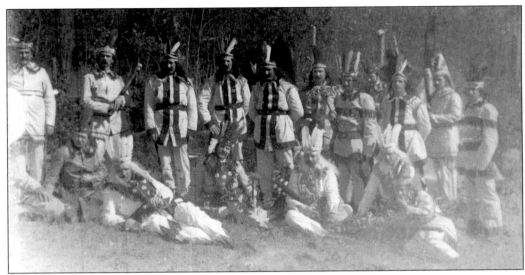

The Improved Order of Red Men was a fraternal organization whose members claimed descent from the Sons of Liberty that participated in the Boston Tea Party. Chief Flatmouth Tribe No. 22 was organized in Walker in 1898 and was a civic-minded group that improved streets, planted trees on boulevards, and built the opera house where they held their meetings. The Red Men traveled to a large gathering in Bemidji in July 1900. They also won the state championship in 1900. The young mascot of the group was Eli Leslie Oliver, the son of A. A. and Elizabeth Oliver. A. A. was the owner and editor of the *Cass County Pioneer* newspaper. Eli grew up to be a labor negotiator in the United States and overseas. He retired to his home on Leech Lake and died in 1987.

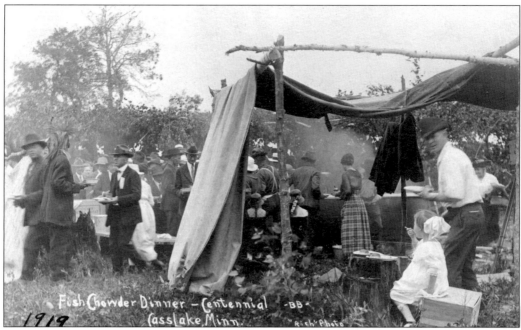

Fish Chowder Dinner — Centennial -BB-
1919 Cass Lake, Minn.
Rich Photo

In the summer of 1919, Cass Lake celebrated the centennial of Lewis Cass's expedition to Red Cedar Lake. Otto Koll, Wesley Kalbfleisch, George Lydick, Fred Potter, Ed Miskella, Dr. G. A. Christensen, and Joseph LaFontaine, who represented the Cass Lake merchants, and Dave Boyd, with other Native Americans, produced a pageant and filmed it. The Northern Minnesota Development Association showed this film throughout the country. Boyd was a well-known Ojibwe man, who also worked as the local policeman. Lydick was active in the development of Cass Lake from the time he moved his family there in 1898 and was elected president of the first citizens' group in 1899. He owned Lydick Mercantile, was a dairy farmer, and usually had logging operations going on as well. Lydick and Jim Van Pelt prepared the chowder dinner.

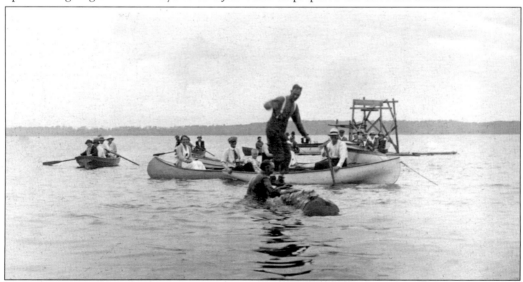

The Knights of the Maccabees was a fraternal organization formed in 1878 in Canada. By 1900, the organization provided low-cost insurance to Cass County members and assisted with funeral expenses. The Ladies of the Maccabees were the first to offer life benefits for women, and their members were many. The local unit participated in many Cass County funeral services and helped families of the deceased.

The Village of Backus built a pavilion for their band near the business district. This postcard mailed to Anamosa, Iowa, on August 30, 1912, had the following message: "Hello Sid: How are you? We are well, had two big rains here. Ask Edd if he knows the man I got marked on this card. There are lots of game. This is all for this time. From John K. Write soon."

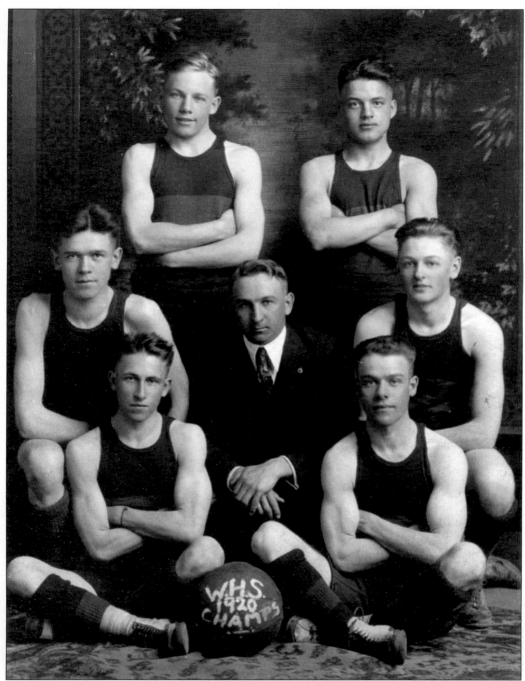

Walker High School champions of 1920 were George Dickinson, Carl "Dutch" Rau, Glenn Bacon, Harold "Cuty" Kulander, Frank Richards, and Earl "Pinky" McDougall. E. A. Swenson was their coach. They played their games at the Walker Opera House. This team was noted to have the smallest players in the state. Walker started the season with only six men on the squad, later losing one, and then bringing the team into the district finals. Walker's speed defeated Bemidji and eliminated them from district honors. Walker played Little Falls at Crosby on March 12, 1920.

Seven

TRANSPORTATION

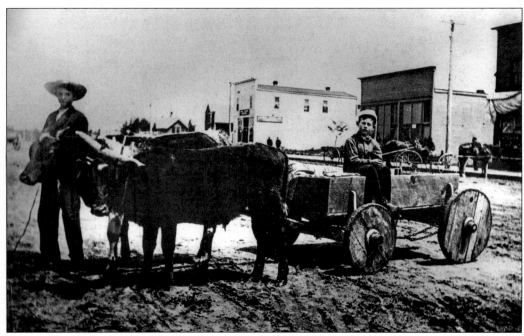

During the early years of Cass County, oxen were occasionally seen on the village streets. Pioneers brought oxen to homesteads to be used on their farms and in the woods. This unusual cart, similar to the Red River carts used by the Metis, was probably custom built by a farmer to save money, as one can see wagon wheels with spokes on other wagons in the background.

This drive is along the eastern edge of Lake May near Walker. A postcard written on August 24, 1925, states, "We are still in northern Minnesota where I love it for it looks so much like home—pine and spruce trees—many lakes and wonderful drives—Wild flowers in abundance—Water lilies too—wish I were to stay longer. Blueberries too. Aunt M."

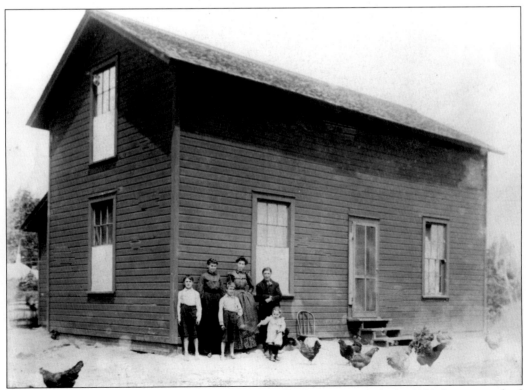

This Great Northern Railway section house was located near Cass Lake by 1899. It was standard procedure for the railroad to allow the section foreman to have his family with him. They kept chickens and many even had a few pigs and a cow near the house.

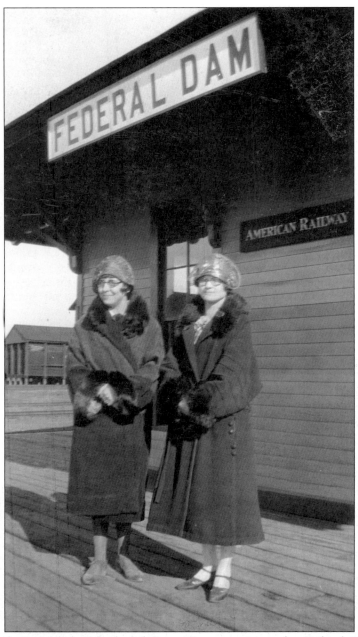

Two local teachers, Mabel Hampl and Rose Crema, wait at the Federal Dam depot for transportation to their homes about 1928. Teachers were assigned throughout the district by the county and often traveled back and forth on the weekends and for holidays using the train. Hampl (left) came from Tenstrike; Crema came from Nashwauk. Crema married Sam Buccanero and moved to the Duluth area. After graduating from Bemidji Normal School in 1925, Hampl's first teaching assignment was at Federal Dam. She loved to dance. Ed McKeig also loved to dance and played many musical instruments. Along with his brothers, he played in the local dance band. With marriage to McKeig in 1929, she had to give up her teaching. In 1943, she resumed teaching at Federal Dam and also grade school in Boy River from 1948 to 1963 until the school closed.

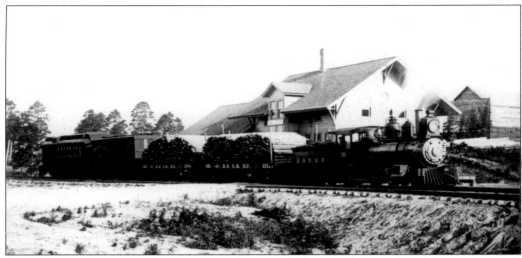

This was the first Minnesota and International Railroad train to arrive in Walker in 1896. The depot was the hub of activity in those early days. Everyone watched trains arrive with loads of logs, traveling salesmen, tourists, businessmen, family members, and freight. After the settlers were established, trains carried their produce and animals to market. Many fishing groups shipped their fish in ice to their homes in the cities. Many bullheads were sent to feed the hungry in large cities by a commercial bullhead project. Native Americans sold wild berries to Walker merchants, who sent large crates of blueberries, strawberries, and raspberries to markets in larger cities to the south. By the time passenger cars were added, there were six trains, three each way, passing through town each day. Trains continued to transport passengers through the 1950s, until the depot was replaced with a new brick building that is presently home to the Senior Leech Lakers Club.

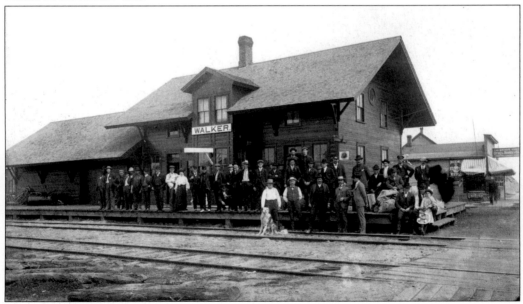

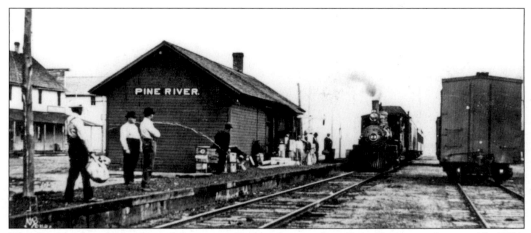

The Brainerd and Northern Minnesota Railroad arrived in Pine River on August 15, 1894. George and Ammarilla Barclay had operated a thriving trading post on the Pine River since 1873. Forfeiting property for the railroad right-of-way, the Barclay's purchased land on the future village site and built a ranch and trading post that had a hotel, store, and saloon in the same building. A frame depot was built in 1913.

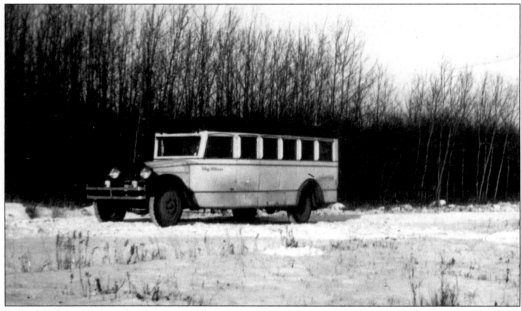

State Highway 80 was created in 1917. Present State Highway 371, State Highway 20, and some county roads were part of the system. The first commercial bus line between Cass Lake and Walker was provided by the Northland Bus Company out of the Twin Cities and the route went through villages along old highway No. 19. The Greyhound Bus Company extended its service to Walker in 1925.

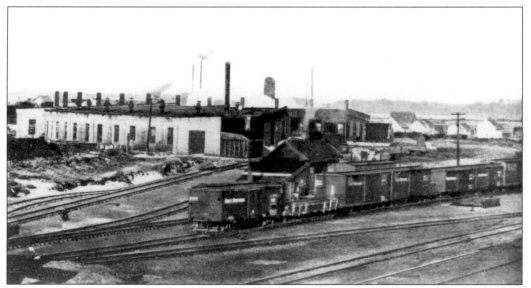

The Great Northern Railway roundhouse, which serviced trains passing through Cass Lake village, was built in 1899. A major explosion in February 1941 rocked the village when the furnace boiler blew up, killing Frank Fadden, Charles Allen, and Lee Young. Lester Bieber, the only survivor, was thrown through a window into a snow drift.

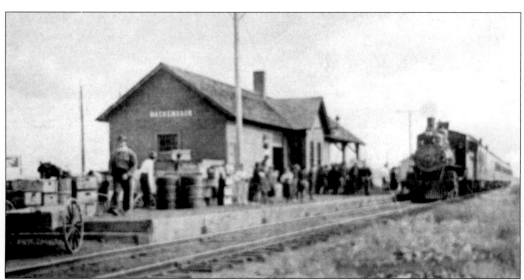

Hackensack's first depot was actually the depot from the abandoned town of Lothrop and was moved in 1904 from the town site into the Hackensack village. William J. Spain Sr., a surveyor and the owner of Hotel Endeavor, made the first plat of Hackensack in 1904 and became the first depot agent for the Minnesota and International Railroad, which succeeded the Brainerd and Northern Minnesota Railroad on July 16, 1900.

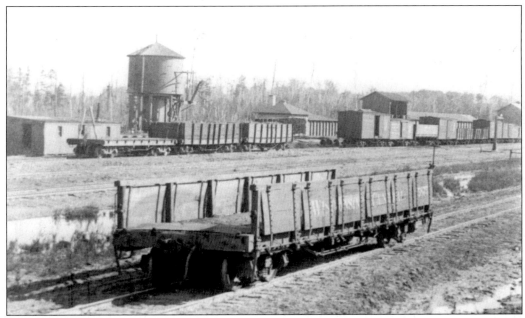

Five cars and an engine of a special freight train were wrecked one mile south of Walker at five o'clock on the afternoon of Wednesday, May 13, 1914. Helper engine No. 9 was also destroyed. The track was torn up for a quarter of a mile and the rails were twisted out of shape. It took the greater part of a day to clear the tracks.

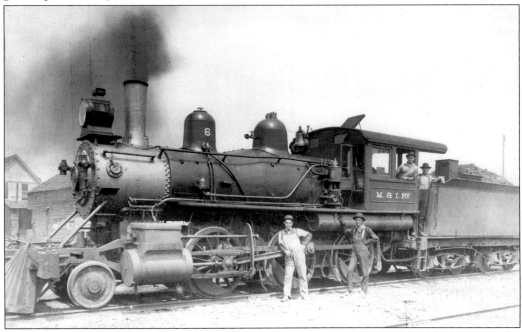

On February 25, 1896, the Brainerd and Northern Minnesota Railroad had laid 59.13 miles of track from Brainerd to Walker by crossing Shingobee Island of Leech Lake via a 1,400-foot wooden trestle. The Brainerd and Northern Minnesota Railroad came into Walker just one month before the village was incorporated. The trestle was demolished in 1986 and was part of the longest abandoned rail line in Minnesota.

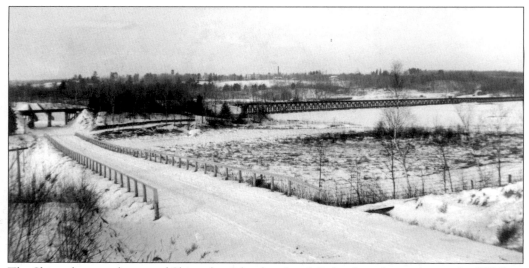

The Shingobee trestle crossed Shingobee Island on Leech Lake about four miles south of Walker. In this photograph, State Highway 34 has not seen the snowplow yet, and the Burlington Northern Railroad overpass crosses the highway. High up on the hill in the distance is a view of the grounds at Ah-Gwah-Ching Tuberculosis Sanatorium, with its landmark smokestack.

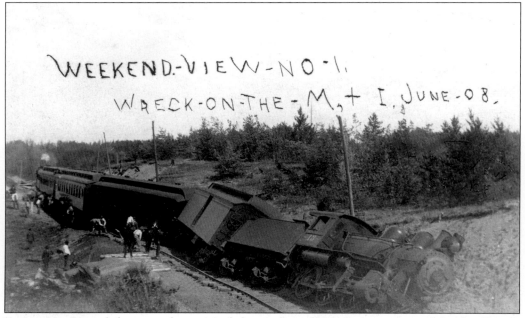

Engine No. 13 and three coaches jumped the tracks early in the morning on Monday, June 1, 1908, near Nisswa. The accident was due to the work of train wreckers, who removed fish plates and spikes and cut into the ties with axes. At the time the tampered track was struck, the train was moving along at nearly 35 miles an hour. There were 50 passengers who escaped serious injuries.

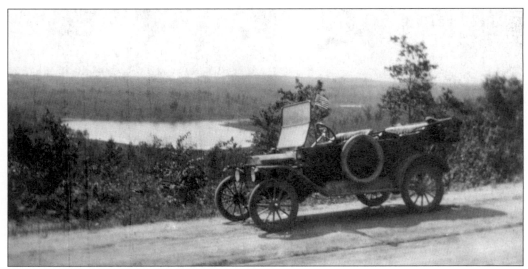

Absalom K. McPherson of Bridgewater, Maine, began working in the lumber industry at age 18. He farmed in North Dakota until 1900 and then moved to Cass County to work for Red River Lumber Company of Akeley and the Pillsbury and T. J. Welch companies. This was his campaign car when he ran for clerk of district court of Cass County, a position he held from 1918 to his death in 1943.

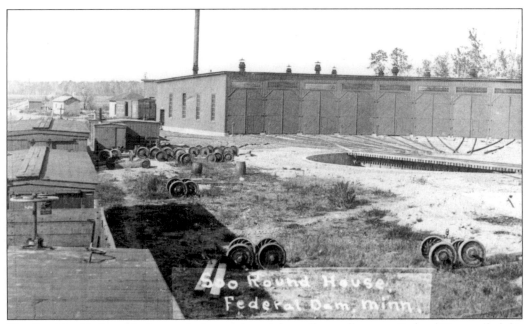

The Soo Line Railroad had a repair shop and an eight-stall roundhouse at Federal Dam called the H. Dahl Roundhouse, which employed 100 men, 24 hours a day, in three shifts. The roundhouse was active for many years. It was destroyed by lightning and a fire in 1941. Bud Palmer took down the last section of it in 1961. The ceiling boards were cleaned with acids, restored, and sold.

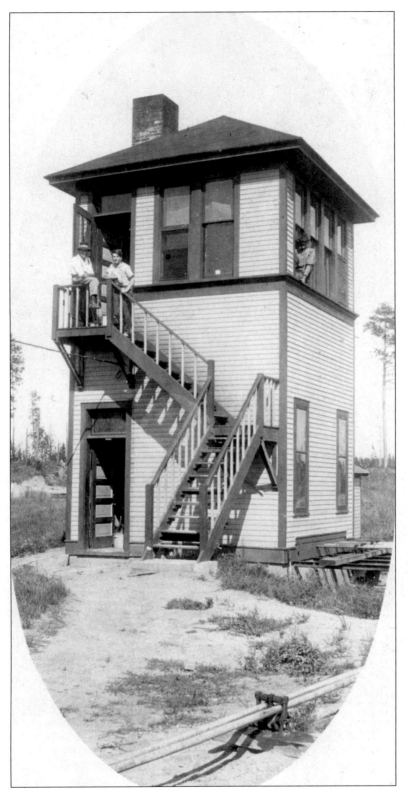

In the early 1900s, the village of Schley was an active town with many people living within a few miles. Today there is only a hint and a memory of what used to be. Schley was an important side track during the logging era. Side tracks were named after popular Spanish-American War officers, and this one was named after U.S. Commodore Winfield Schley. The town was originally on a segment of the Burlington Northern Railroad line from Duluth to Cass Lake. A station was built and abandoned in 1899. This two-story crossing tower at Schley was built by the Soo Line Railroad in 1910 when the segment from Federal Dam to Plummer was completed. James Agnes, Peter Kornezo, Robert Peterson, Ole Simonson, and Richard Zuelow were section foremen. Harry C. Davis and his son Leo were towermen. Paul Gorr was the telegraph operator.

The tracks of the Soo Line Railroad were laid through Federal Dam in 1910. The first train went through on November 14, 1910. This was a terminal or division point with trains going from Superior, Wisconsin, to Federal Dam and back and from Thief River Falls and back, so many trainmen lived at Federal Dam. The last train went through in the spring of 1986. All signs of the yard are now gone.

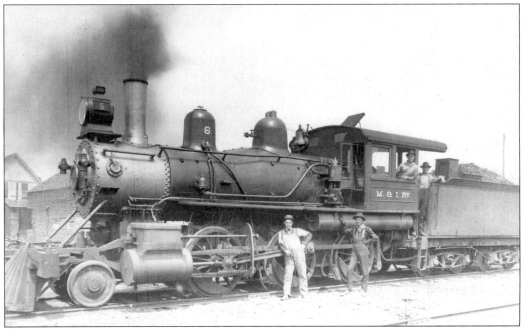

This Minnesota and International Railroad crew is relaxing at Walker before there was a roundhouse for maintenance. The size of the frame-built roundhouse at Walker is unknown but was built in 1898, nearly two years after the first train arrived. It was only used until 1899, when the rails reached Bemidji.

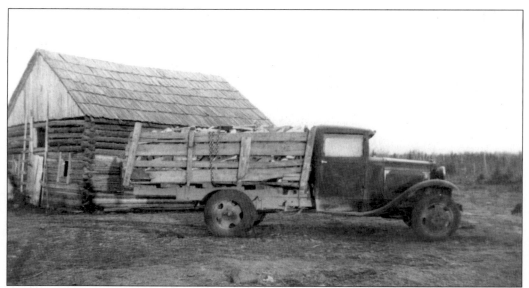

William E. Winegarner purchased property in Section 21 of White Elk Township in Aitkin County, where Cass and Crow Wing Counties meet, and began building a log house in November 1916. Cold weather forced him to discontinue building, and the house was lost in a forest fire the next spring. In the fall of 1917, construction of a log barn was more important than a house.

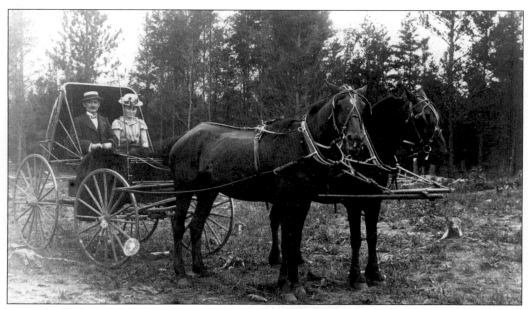

This couple drove away from the village in this conveyance, better known as "the courtin' buggy" in 1898. The tree stumps indicate that someone cleared this spot out of the forest. The cemetery was usually the first place cleared off. If one looked in the buggy, one might see a picnic basket, as most early picnics took place on cemetery grounds.

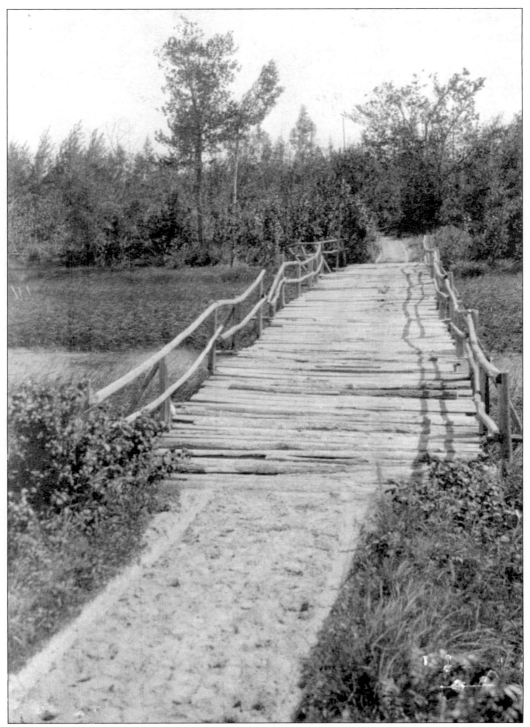

This is the south end of the Shingobee bridge that crossed Shingobee Bay on Leech Lake in 1917. Bridges on the north and south ends of Shingobee Island provided ways for people to travel to Walker that were much shorter than the trip down County Road 50 to Highway 34 and around the east side of Lake May.

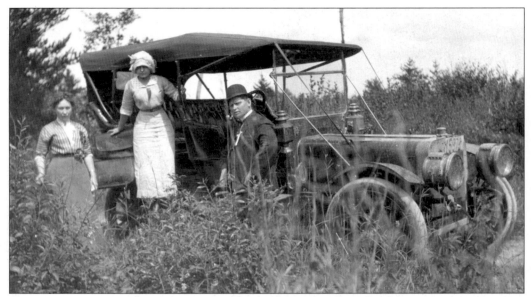

Bert Jamison worked at the Akeley business, Sheers and Geise, as a bookkeeper. He ran for the office of judge of probate of Cass County in 1908 and served in that capacity from 1909 to 1925. Here he takes his sister Gertrude and her friend Hannah for an outing in his car, which was one of the first cars in Walker.

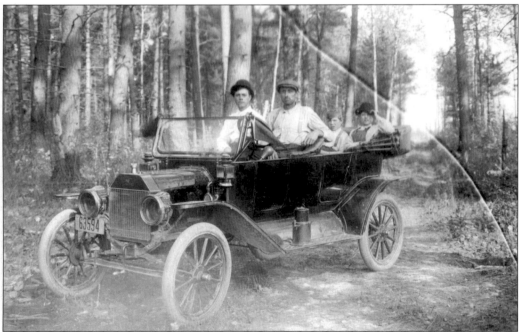

David Clabaugh (driver) built and operated a mercantile store in Remer and sold it to the Wittwer family in 1918. Seated next to him is Charles Fletcher, who had a farm six miles southeast of Remer. Fletcher spent his life at Remer and died at the age of 102. Clabaugh bought property on the commercial block of Federal Dam in 1921 and established D. A. Clabaugh and Company, which sold lumber, lath, and shingles.

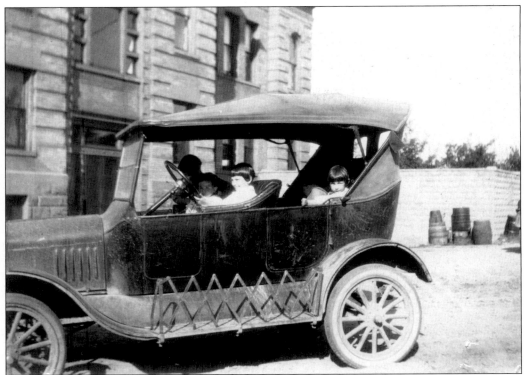

Lionel G. (Owen) Morical, who was born June 11, 1875, in Indiana, came to Minnesota with his parents. He arrived in Walker in 1907 and was a resident for 33 years. He held the office of Cass County sheriff from 1923 to 1931. He married Georgia Tracy and had children Leone, Tracy Lorraine, Edward, Julia Anne, Ora, and Leslie.

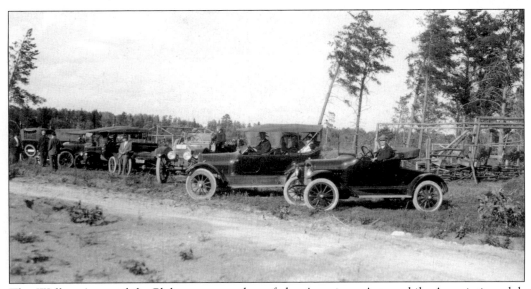

The Walker Automobile Club was a member of the American Automobile Association club in the early 1920s. Sunday summer driving tours complete with picnics were all the rage. The Minnesota State Agricultural Society presented the club with a silver cup for the most mileage in the 1918 state fair automobile club tour and it can be viewed at the Cass County Museum.

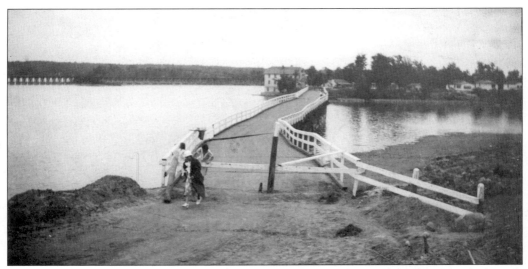

This was the improved bridge on old highway 19, which crossed over Shingobee Island of Leech Lake in the early 1920s. The Island Hotel, built and owned by Ben LaPoles, opened for business in April 1932. In just a few short years, a new road was built along Leech Lake on the western side of the island.

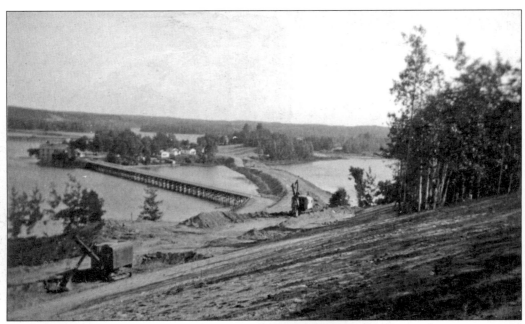

By the fall of 1933, construction of a new road was in full swing. Workers and equipment were scarce. The project was taken over by WPA and hundreds of CCC boys were put to work replacing the south bridge at Shingobee Island with fill and the north bridge with concrete and steel. Many men and boys camped in the area in large canvas tents.

Eight

LAKES AND RECREATION

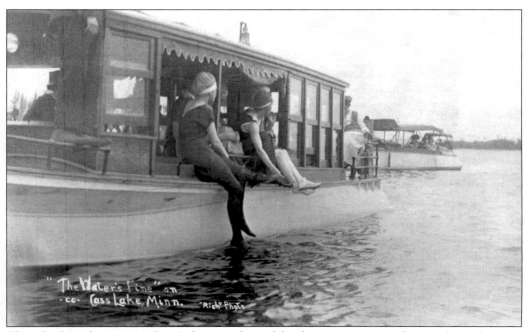

These bathing beauties at Cass Lake were dressed for the occasion according to the early-1900s swimming etiquette, with short, woolen dresses and black, woolen stockings. This was common regardless of how warm the day was. One can just imagine how that wet wool smelled. Most bathers just waded, as a dip in the water added weight to the suits.

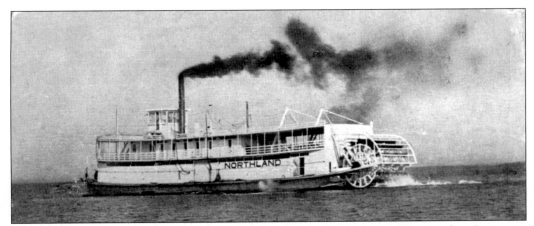

The *Northland*, built in 1907 for Jimmy Long and the Northland Pine Tree Lumber Company, had three decks, was 135 feet long, and was wired and lighted. Thomas J. Welch used it in his logging operation and then sold it to Jay J. Berkin and the Walker businessmen to use as an excursion boat in 1915. It was dry-docked, and John Andrus used its timbers to construct Tianna Farms in the early 1930s.

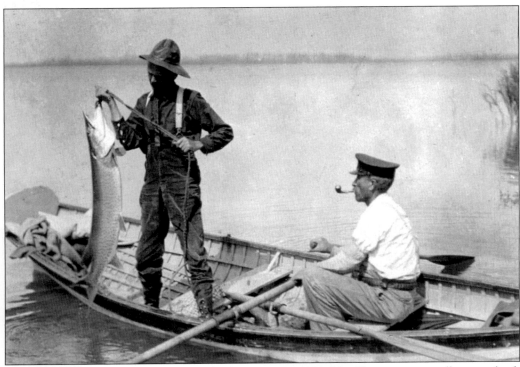

Leech Lake lends itself to exaggerated fish stories. In 1901, Mr. Cheney supposedly came back to beat his record of a 35-pound muskie. Loren Chase advised him to harness a rat, hitch a hook to it, and take it to Walker Bay. "I wish you could have seen us, how ridiculous we looked, 450 pounds being towed around in Leech Lake by a rat!" Forty minutes later, he hooked a 71-pound muskie.

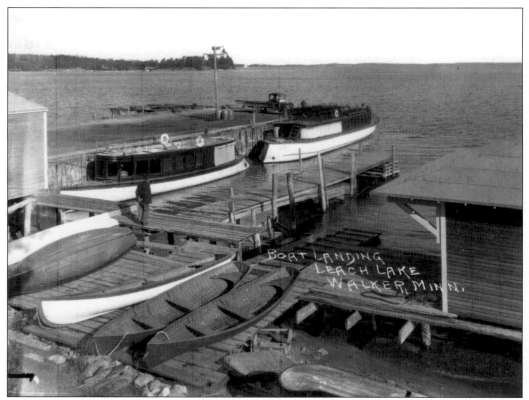

The city dock and boat landing was one of the first projects of the Walker townspeople in 1896. Two launches are moored, waiting for fishermen. The Walker boat livery was located here in 1907 and rented out rowboats. A bowling alley was located south of the dock at the top of Michigan Avenue to provide entertainment for those who were not interested in fishing.

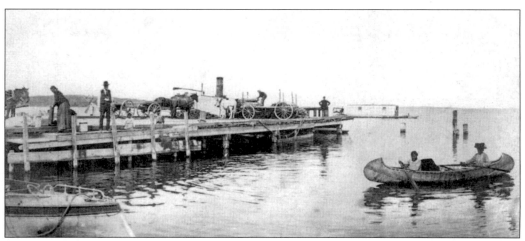

The dock was the hub of activity. Native Americans stopped here before going on to the Indian Agencies. Red Lake was to the north; White Earth was to the west; Leech Lake was to the east, and Crow Wing was to the south. Settlers brought household items here by train, transferred them to the dock area, and rented steamers to take them to their homesteads located around the lake.

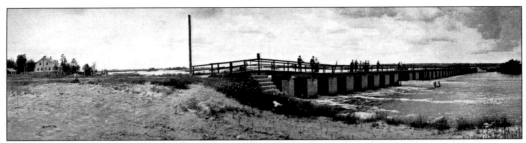

Construction of the Leech Lake dam, the second in the Headwaters Reservoir System, began in 1882 with a crew of about 300 workers and began full operation in 1884. Many workers were the Ojibwe, who lived on the Leech Lake Reservation, including Josh Drumbeater, Charlie Campbell, and Walt Seelye. George White planted the trees near the dam tender's quarters. The dam, rebuilt in 1898, had a 12-foot sluiceway for logs that was used until 1931. The recreation area around the dam attracted hoards of visitors, and on Sundays the area was filled with picnickers. Bands from various towns provided music. This group (below) was known as Geisler's Geezers, with the following members from Walker: Rollie Hawkin (leader), Harry Bright, Ernest Croff, Fred Finn, Johny Kamberlin, Fred Mengis, Will Gates, Gus Nordquist, Ben Oliver, Charley Pion, Roy Still, Floyd McNamar, Elmer Kulander, Gus Kulander, and Farley Dare.

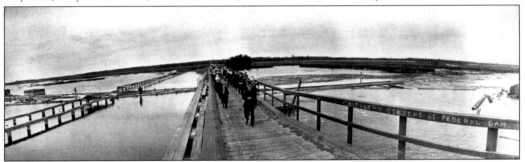

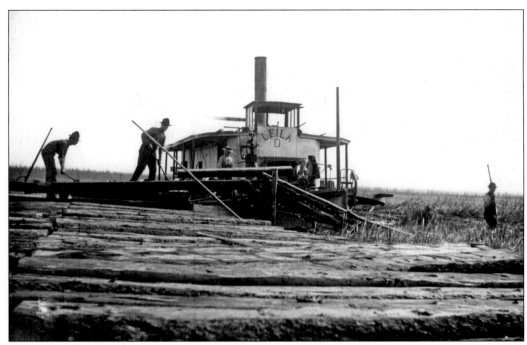

The *Leila D.* was the first privately owned boat on Leech Lake. Built by Nate Dally in 1895, it took many pioneers to their homesteads, delivered supplies to Old Agency, and carried building materials for construction at the dams. In the upper photograph, men are trying to position the *Leila D.* at the steamboat landing. The boat carried provisions that were loaded onto wagons for sale to the settlers, including barrels of whiskey and beer for the Bemidji saloon merchants. The Dally family stayed in living quarters on the boat. In the lower picture, the *Leila D.* is taking on a load of passengers for a tour around Walker Bay. A small ensemble was seated on the top deck to play the favorite tunes of the day. The tour likely included a picnic at Old Agency and entertainment in the form of a powwow, races, or baseball game.

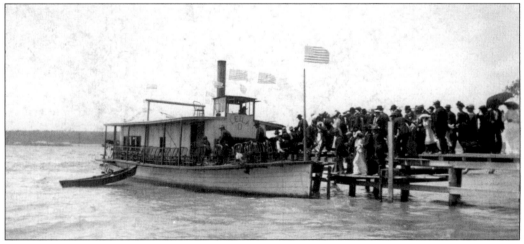

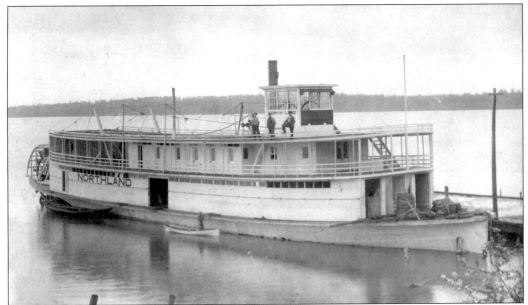

The *Northland* was built in 1907 by Jim Hill of Stillwater. Axel Strand was the engineer. Thomas Welch purchased the boat to furnish logs for his mill on Moonlight Bay of Leech Lake. He and his daughter Mary Welch lived on the boat during the summers, which she referred to as "the mind and heart of my summertime world." After working as a war correspondent during World War II, she married Ernest Hemingway in 1946.

The Walker boat service was owned by Walter Haberman in 1924. Lawrence Trettle became owner in 1929 and began delivering mail by boat. Harold and Don Fisher were the last owners, with carriers Herman Fisher, Clarence Fisher, Don Fisher, Harold Fisher, Don Jacobson, and Bud Draper. From May to October, the 75-mile route over Leech Lake included passengers as well as mail. The mail boats were discontinued in 1977.

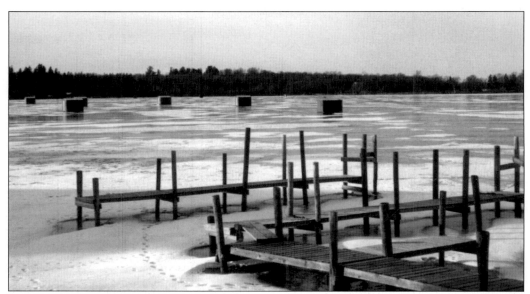

When the weather turned cold and game became scarce, early residents set out shelters on the frozen lakes. Early in the morning and late in the afternoon, these houses were occupied by fishermen attempting to provide food for the table. Some shelters were even occupied overnight. Thin ice was always a danger. Several legends among the Ojibwe are associated with the booming and cracking of the ice at night.

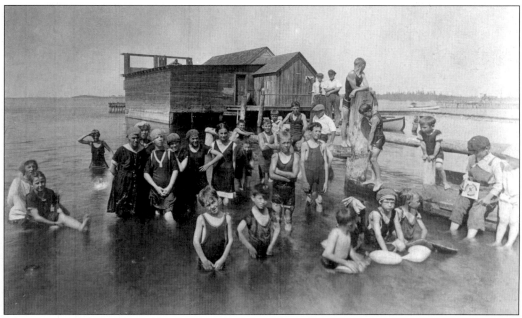

This is one of the many public beaches maintained by the city of Walker over the years. It was located directly in front of the Chase Hotel in the 1920s. The children took time out from their summer fun to pose for this photograph in their bathing suits.

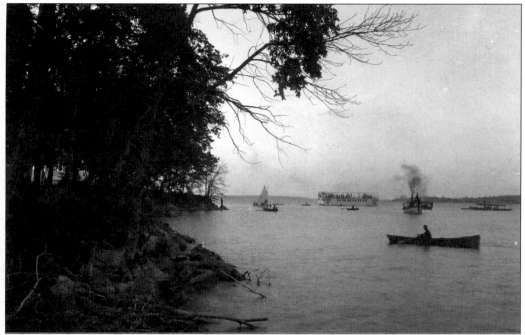

P. H. McGarry's *Ark*, a floating resort and dance pavilion, was built in 1901 by Akeley Lumber Company and was first used as a wanigan. The *Belle*, owned by Judge Ely Wright in 1898, hauled logs in Kabekona Bay. The *Myrtle D.*, the first government-owned steamer on the lake, was the Leech Lake Agency boat. Wright sailed the first sailboat on the lake in 1896.

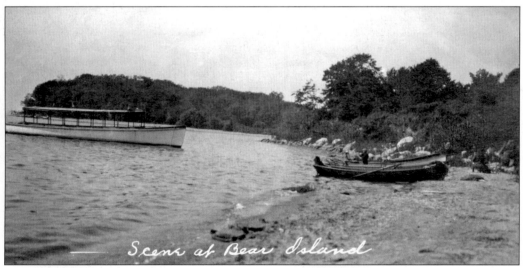

Scene at Bear Island

Bear Island is an island in Leech Lake. The Ojibwe named the land Mah-Qua-Me-Nes, which means that there are many oak trees and many bears on the island. The Pillager band of northern Ojibwe maintained a large village here in the 1700s and 1800s. Here fishermen in rowboats are leaving the launch, *Megowatt*, for the Bear Island shore, where they will have lunch.

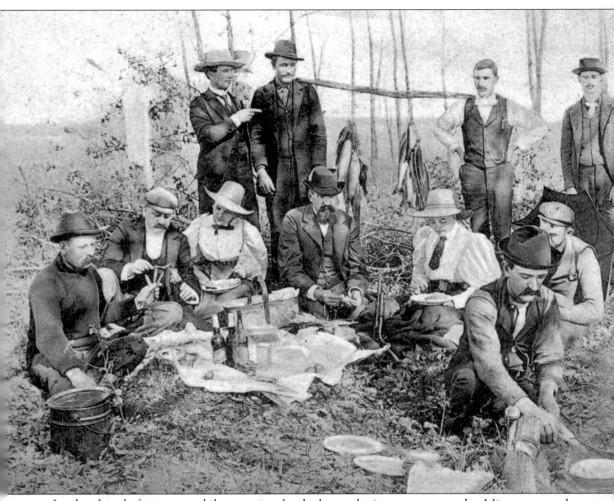

In the days before automobiles, tourists booked round-trip passages on the Minnesota and International Railroad or the K Line of the Great Northern Railway from Minneapolis to Leech Lake for just 50¢. Launches towed the rowboats through the narrows out to the big lake. Guides then rowed the boats that carried two fishermen in each boat. Rusty Geving, for example, began his career as a guide when he was only 14 years old. It was standard practice for the guides to cook a shore lunch if the fishermen were lucky enough to catch any fish. After lunch, the party returned to the lake to replenish their catches. There was nothing better than fresh walleye. This postcard was mailed from Walker on June 2, 1913.

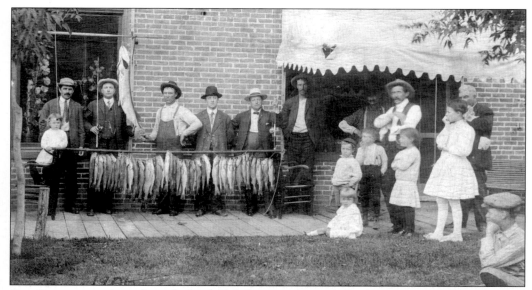

Cass County superintendent of schools Bob Ross was the guide for this group of Walker fishermen in 1906 on Leech Lake. Loren Chase was owner of the Chase Hotel, A. A. Oliver (with hat, second from right) was owner of the *Cass County Pioneer*, and Hunter Bright (bottom right) was the son of Wilford Bright, who owned Bright's Mercantile Company.

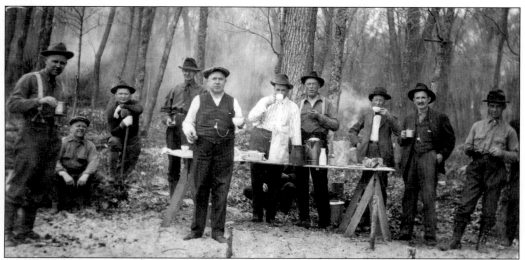

This group of Walker businessmen and courthouse department heads steamed over Leech Lake to Otter Tail Point for a little fishing and a shore lunch on May 16, 1920. From left to right are W. T. McKeown, county treasurer; Ross, superintendent of schools; Tom Hammond, village treasurer; Clayton Bacon, auditor; Ed I. P. Staede, banker; H. L. Wilcox, doctor; J. S. Scribner, county attorney; George Upham, druggist; A. K. McPherson, clerk of court; and Robert DeLury, former sheriff.

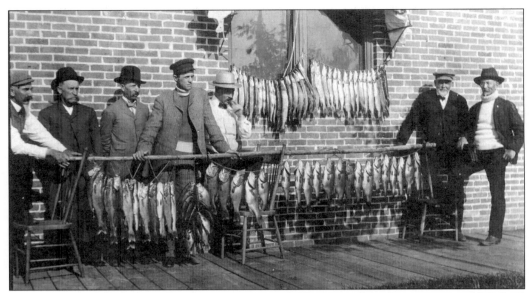

These fishermen, Sandusky, Beasley, Smeltzee, and Chase, caught a large variety of fish from the northern lakes in Cass County. Fish of all kinds were abundant in all the lakes; experienced men needed just a few hours to bring home stringers loaded with fish.

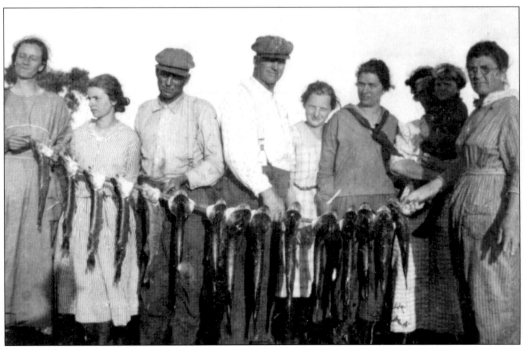

T. B. Reid and his family first drove their new Haynes car from Tama, Iowa, to Federal Dam in 1916. The Reids eventually bought property at Five Mile Point and visited the property regularly until 1976. This photograph was taken after a day's fishing with friends in 1920. From left to right are Mina Harris, Carrie Reid, Bill Harris, T. B., Beryl Judy, Helen Reid, Mrs. Judy holding Edith Judy, and Lizzie Reid. Glenn Judy was the government farmer for the Chippewa Indians at Sugar Point.

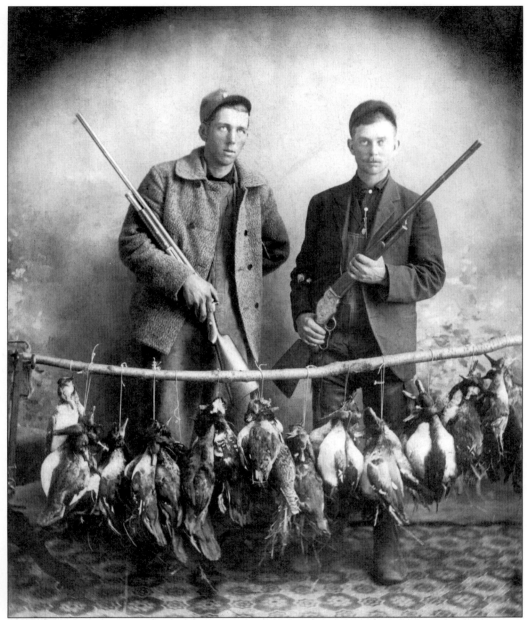

Ray Malmquist (left) and his friend pose after a successful day of duck hunting. This photograph is dated about 1900. Northern Cass County, with all its rivers, lakes, and ponds, was a hunting paradise around 1900. The submerged vegetation in the sloughs and lakes of the Mississippi headwaters and the remnants of the wild rice stands made the area a wonderful stopover for migrating ducks and geese.

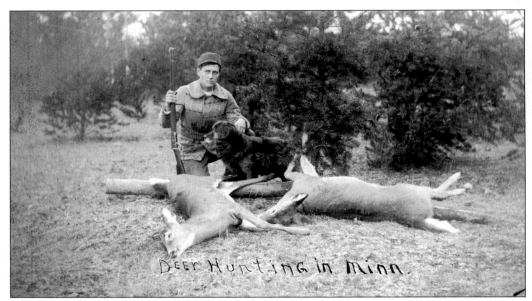

Henry DeWald and Old Grace enjoyed a successful deer hunt on November 11, 1906. DeWald's parents had the store at Poplar Corner for several years until it burned. He married Hattie Wheeler and had two boys, Hollis and Gale. His family remembered his singing and whistling around the farm. When the wind was right, one could hear him a mile away. He was an accomplished photographer and poet.

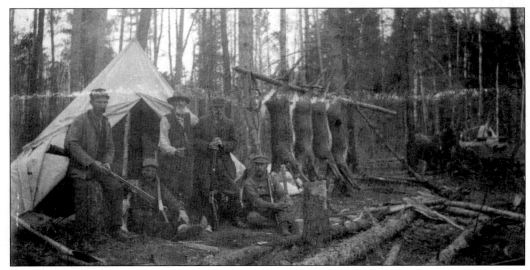

Deer hunting was not much of a sport at the dawn of the 20th century, as it was necessary for survival during the long, snow-filled winter months. Many pioneer families supplemented their food supply with wild game. These men were evidently experts in the art of hunting.

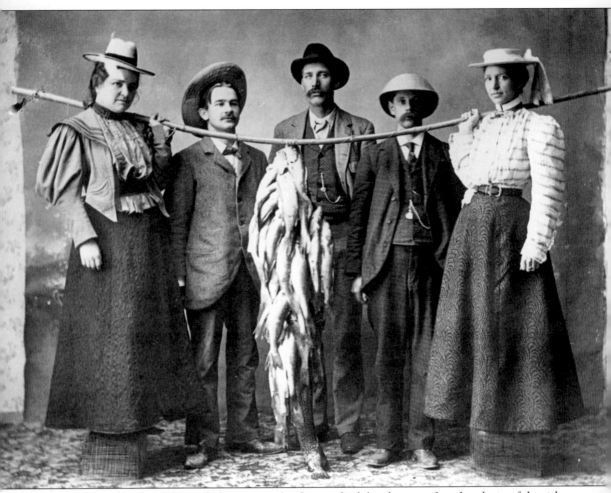

This group of successful city slickers spent the day on the lake chasing after the elusive fish with their cane poles. Afterwards, they walked over to the nearest photographer's studio to have their memories captured on a glass negative. Leech Lake is Minnesota's third-largest lake and one of its most productive fishing lakes. It is also one of the top muskie lakes in the country. The name Leech Lake comes from an Ojibwe name meaning the "place of the leech." Legend says that on first coming to it, the Chippewa people saw an enormous leech swimming in the lake.

Nine

RESORTS

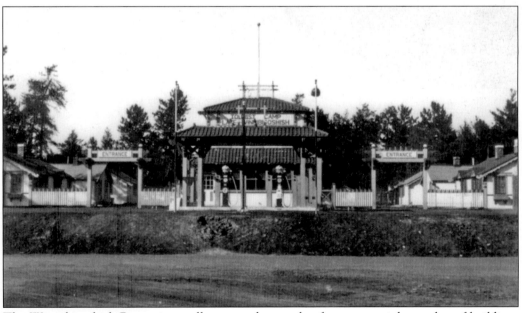

The Winnibigoshish Resort is a well preserved example of a commercial complex of buildings directly related to early automobile highway travel. It was built in 1933 along Highway 2 on the shores of Lake Winnibigoshish by Ernest Flemming. The business has been owned and operated by the same family for five generations. Arnie and Sis Dahl operated it for 32 years. It was placed on the National Register of Historic Places in 1980.

John and Myrtle Huffman established the first resort on the north shore of Boy Lake about 1911. The resort was mostly for fishermen who came by rail as far as Boy River. He picked them up and transported them by boat to Camp Nebe-Wa-Nibi. In 1914, for $2 a day, one got fresh farm produce and a cottage for the night.

Aaron Spain was the first proprietor of Wi-Wi-Ta Camp on Woman Lake near Longville. He began building cabins in 1917 and owned the camp for 20 years. A. B. Rolfe began improvements in 1937 and remodeled the lodge. The resort was sold to a developer and went into private ownership in September 1992.

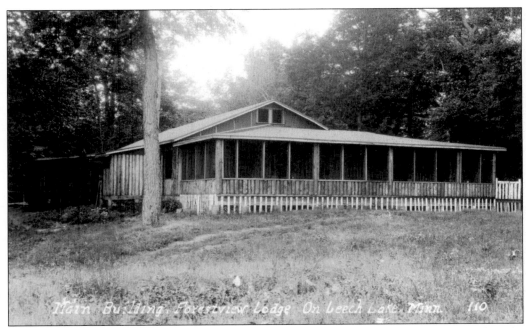

Forestview Lodge was built by John and Van Nobles and Mr. Delp on 71 acres along Leech Lake in 1924. A lodge and 17 cabins were built out of cedar logs that were brought across the ice from Cedar Lake by the local Native Americans. Over the years, the resort hosted many conventions. The resort was sold in 2002 to a developer who removed all the cabins and built private homes.

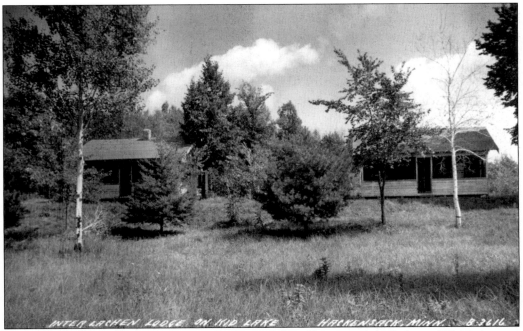

Work on Interlachen Lodge began on a little strip of land between Baby Lake and Kid Lake near Hackensack in May 1920. The resort offered 20 cottages as well as camping. In 1920, shares in the resort sold for $25 each. The lodge itself was destroyed by a suspicious fire in September 1923. The property is in private ownership today.

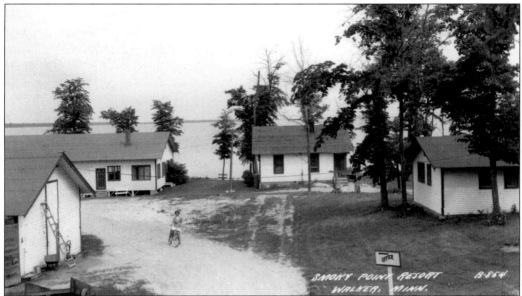

Arthur "Smokey" Dallaire served in France during World War I. After his discharge, he was a patient at Ah-Gwah-Ching, a state sanatorium for tuberculosis in 1920 and 1921. Dallaire, John Remey, and Chris Jackson decided that if they ever were cured, they would buy some property on Leech Lake. In 1922, the men built identical cabins, using stone from the beach for their fireplaces. A fire destroyed many beautiful pines near Smokey Point in 1922. In 1925, Dallaire started building Smokey Point Lodge with the assistance of Frank Marshall, a local Chippewa guide. Dallaire bought an additional 40-acre tract in 1930 and added more cabins. He had slot machines that were moved out of sight when the inspectors came. Dallaire was very patriotic and the resort became a popular meeting place for veterans. He sold the resort in 1961, which operates under the name Spirit of the North today.

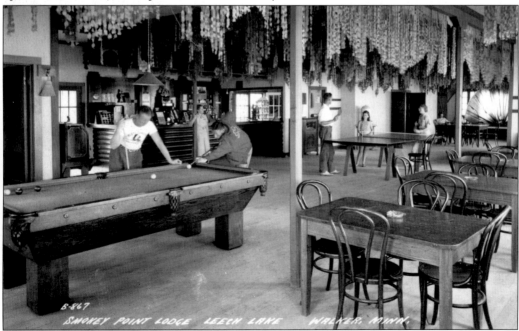

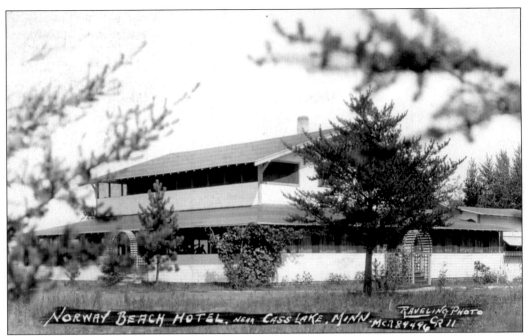

NORWAY BEACH HOTEL, NEAR CASS LAKE, MINN. MC.28449. G.11

RAVELING PHOTO

Norway Beach is part of the original 10 sections that made up the early Minnesota National Forest established in 1908. It was named for the 250-year-old virgin Norway (or red) pines in the area. The Norway Beach visitor center was built in the 1930s by the CCC. Many guests take advantage of the free forest service lectures at Norway Beach Lodge, which provide an opportunity to hear about the forest and its inhabitants from those who manage the Chippewa National Forest. Four campground loops are in the Norway Beach recreation area. The Norway Beach Campground is adjacent to Cass Lake. There are numerous walking paths to the lake. The Norway Beach recreation area now includes the Mi-Ge-Zi Bike Trail.

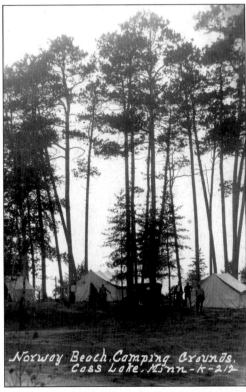

Norway Beach Camping Grounds, Cass Lake, Minn-K-212

Lon Ivins purchased New Agency Bay Camp is 1929, built a new resort, and changed the name to Ivins Resort in 1932. Ivins sold it in 1935 to Chris Jensen, who renamed it Birchwood Resort. Jensen sold it to Willard Springborn in 1946. Springborn sold it to Bill and Adele Safranek in 1951. In the 1960s, it was sold to Loren and Eleanor Alderson. The property has been platted and sold off in lots.

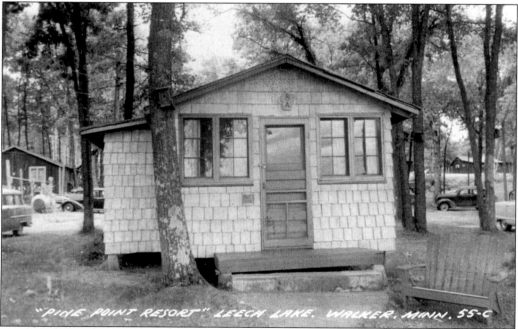

Modern conveniences such as a water system, electric lights, and telephones were unknown in the early days of the resorts. Carr Electric, owned by Joseph Carr, was awarded the job of wiring Pine Point Resort in 1949. Pine Point Resort was sold in November 2004 to D. W. Jones, an area developer.

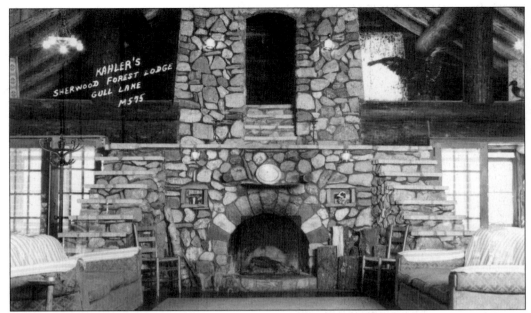

Sherwood Forest Lodge was located between Gull Lake and Margaret Lake. A lodge and 20 cabins were built about 1929 during the first major wave of Minnesota resort construction. Kermit and Natalie Johnson owned and operated Sherwood Forest Lodge from 1959 to 1972. The lodge complex was placed on the National Register of Historic Places in 1980.

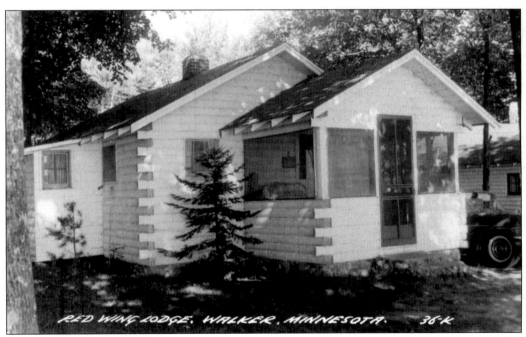

Gilbert Adams owned and operated Red Wing Lodge on the southwest corner of Leech Lake from 1949 through 1960. He sold to a Mr. Greiner and moved to Keota, Iowa. The resort was later owned by Bob and Shirley Quinn. Kyle and Nancy Benjamin are the current owners. The resort has a protected harbor, sites for recreational vehicles, and 14 units.

Arzelia Thompson sold Horseshoe Bay Lodge on Leech Lake to Chris Jensen in 1947. John and Dora Boulcott operated the resort from 1953 to 1960 and won considerable fame as champion muskie fishermen. In 1959, John saved several members of an Oklahoma fishing party when high waves swamped their boat. In 1999, Ron and Sandy Stachura built the Pioneer Inn Courtyard as a conference and reunion center and part of the Horseshoe Bay Complex.

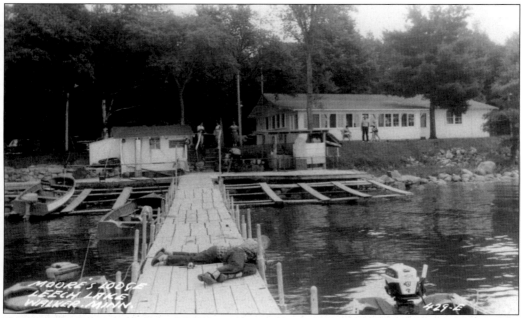

Tom Seevers first came to Cass County in 1929 and built Seevers Resort on Agency Bay in 1931. In 1941, John Sheldon (Shell) Moore rebuilt the property and renamed it Moore's Lodge. Moore was employed by the railroad for 43 years prior to operating the lodge. It was sold to Walter and Gloria Reed in 1964 and sold again in 1973. In 1984, it became Moore's Resortominium. The current owners are Mark and Barb Christianson.

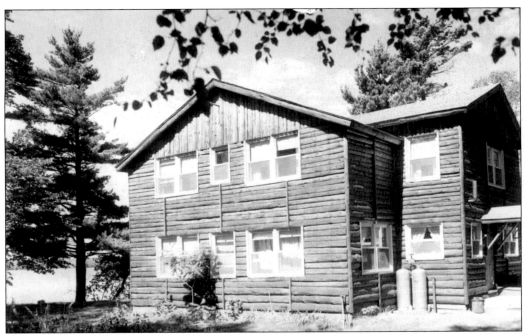

Horseshoe Island Lodge was a rustic lodge on a wooded island in Woman Lake, built as a honeymoon cottage by a Twin Cities businessman. The island is shaped like a horseshoe. Alec and Gertrude Rolfe bought the lodge after selling Wi-Wi-Ta Resort in the 1940s and sold it in 1956. They served meals daily. Fishing boats were furnished, and there was a sand beach for swimming and water sports.

Walker Cabin Camp was located on the west end of the Walker City Park. This eight-cabin camp was operated by Stella Engelmann for two years before Frank B. Lueck took over in the spring of 1938. Lueck built a 12-by-18-foot structure with complete kitchen and dining room facilities for overnight guests in 1939. They sold the camp to Lynn Moran in 1945.

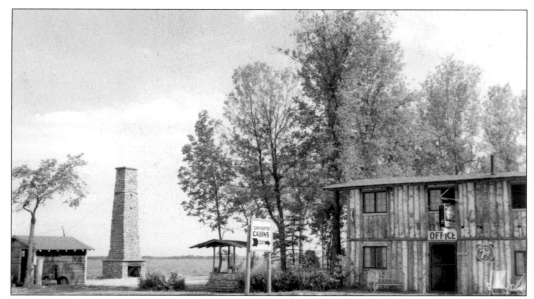

Sah-Kah-Tay Resort is on the southwest corner of Cass Lake. Sah-Kah-Tay received its name from Chief Green Hill. The main lodge was destroyed by an ice flow off Cass Lake, and only the chimney of the original lodge stands today. Walter Dahmrosch, a renowned conductor from New York, sometimes played piano at the lodge. A. O. Hanson purchased the resort in 1946 after it was closed for several years during World War II. The current owners are Larry and Virginia Beaver.

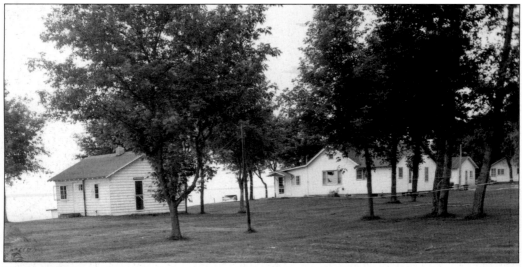

Herman's Resort on Leech Lake was owned by Herman Storhaug, who was born in 1892 in Norway. He applied for naturalization while living in Cass County. Ralph Storhaug owned the lakeshore from 1934 to 1936. Andy Kopiska bought Herman's Resort and Krawczyk's Resort and combined them to make up Sugar Point Resort. The eight cabins near the lodge were Herman's Resort.

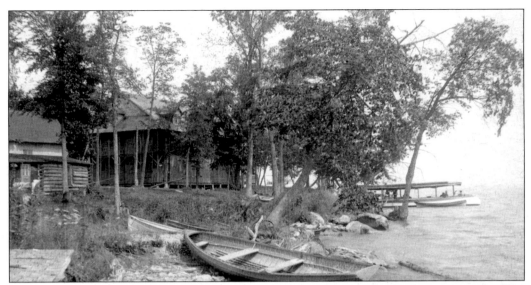

When Second Point on Leech Lake opened up to homesteading, P. H. McGarry encouraged his daughter Edna to file a claim at the Cass Lake land office. Two cabins and a dining building had been built by the Red River Lumber Company, and P. H. added four more cabins and enlarged the dining room in 1902. This was the first resort on Leech Lake, named White City. Its name was derived from 12 sleeping tents first used to house its guests. Guests and supplies were hauled almost two miles by rowboat because the tote road leading to Glengarry Point was so poor. P. H. later purchased his own steamboat, the *White City*. By 1919, the resort had been modernized, eight more cottages were added, an annex had been built on the clubhouse, and a dance pavilion was located near the shore. That year he began calling his resort Glengarry Springs.

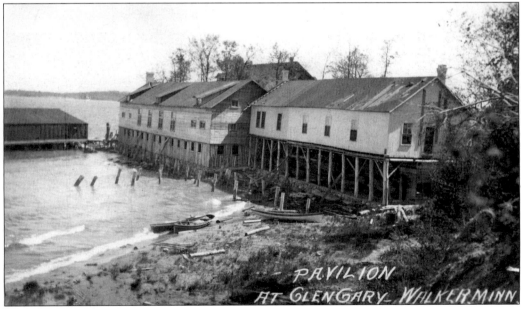

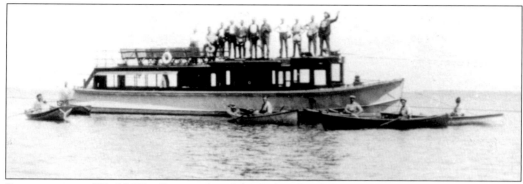

Resorts prior to World War II catered to fishermen. This fishing group from New Ulm enjoyed a day on the launch *Megawatt* in 1923. On the roof from left to right are James Beecher, Henry Somsen Jr., Edgar Veeck, Henry Flor, Henry L. Beecher, Henry Somsen Sr., Fred Johnson, Edward Stoll, Roland Hohn, mate, and Captain Reynolds. Gill James was the lead guide. Six other guides, all Native Americans, are in the rowboats. The second photograph shows the smaller group, which includes, from left to right, Veeck, Stoll, Beecher, Johnson, Somsen, and Flor. Before commercial bait was available, each fisherman had to invent his own bait. Henry Somsen Jr. remembers cutting a tiny pair of britches from a piece of red flannel and using a fish tongue from the previous day's catch. He bragged about what a killer bait it was. This method is outlawed today.

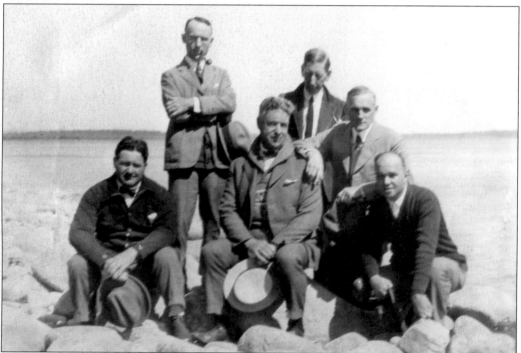

Ten

PEOPLE

Frank and Agnes Bragg
opened Bragg Hardware
of Walker in 1916 and
operated Walker Lumber
Company from 1921 to
1928. Their daughter Maude
(pictured) married Leland
Orton. The Ortons owned
the following businesses:
Red Owl Grocery in
Longville (1925), Backus
Locker Plant (1947), the
Ford Motor Company
dealership (1949), and
the Red Owl Grocery in
Walker. Maude helped
with the organization of
the Cass County Historical
Society and the Cass
County Museum.

Synva Thue Quam was born August 1, 1883. In 1907, Thue, a newly graduated nurse from North Dakota, accompanied Jonas Linden, who lay drugged with morphine in a baggage car to Pine River. She became the head nurse at the Walker hospital and married Martin Quam, a local businessman, on October 15, 1908. She worked at Ah-Gwah-Ching from 1943 to 1950. Quam Court apartments are named in her honor.

Edna McGarry (right) is shown with Bill and Margaret McGarry. Edna filed for a homestead at the Cass Lake Land Office in 1903 on White City, the first Leech Lake resort, which her father P. H. McGarry had begun operating in 1896. Bill was a nephew of P. H. McGarry. Margaret, Bill's wife, was Walker postmistress from 1933 to 1966.

Joe and Edith Oscar, ages 27 and 25, respectively, had two children, William and Margaret. The family resided at the Leech Lake Agency, where Joe was an engineer for the agency boat the *Vera*, which carried supplies and children to and from the agency. In the first minutes of the Sugar Point battle, Joe's arm was shattered by a bullet, leaving him crippled. He received a $700 settlement.

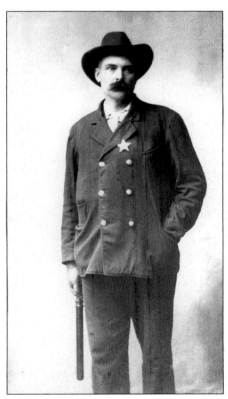

Ed Harris was hired as the village marshal at Walker in May 1898 and was the chief of police during the Sugar Point battle. His left arm was shattered by a rifle ball that hit him while he was helping to pilot a steamboat during the battle. He was granted a lifetime pension of $12 a month in 1900.

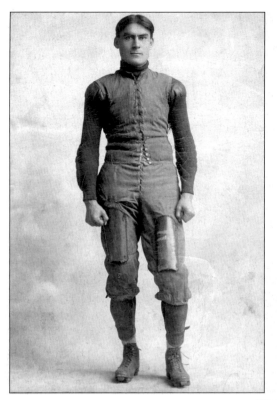

Ed Rogers served as Cass County attorney from 1912 to 1962, except for the years 1928 to 1932. After attending Carlisle Indian Industrial School in Pennsylvania, he captained the University of Minnesota football team in 1903. In the 1960s, he was elected into the National Collegiate Hall of Fame and into the American Indian Athletic Hall of Fame.

Charles Kinkele came to Walker in 1896 and supplied Old Agency with beef. He built the Lake Shore Hotel in 1896, was vice president of the First State Bank of Walker, owned the Kinkele Furniture and Undertaking business, and helped build St. Agnes Catholic Church in 1914. He was elected the first mayor of Walker in 1896.

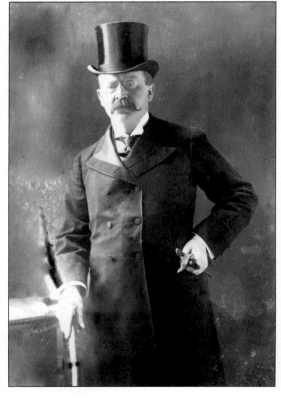

Martha Jane Lawr was born in 1863 in Canada. She and nephew William arrived in Walker before 1900 from Michigan, opened the M. Case Saloon and pool room about 1904, and sold out to Albert Carlson in 1908. They both operated a saloon and billiard parlor in Remer. When William died, Martha sold the business in 1929 to A. O. Rosdahl, and he moved it to the Remer Hotel.

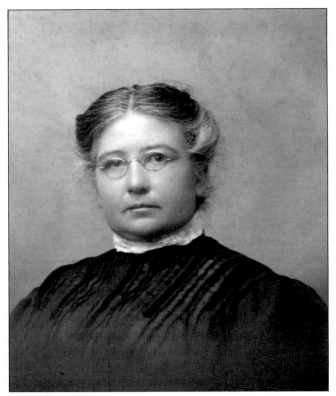

Martha Brevik (far right) was born in 1899 to Ole and Lena Brevik. In 1912, Ole homesteaded 80 acres in Boy Lake Township. Martha boarded at Charlie Bilben's in Walker while she attended high school and the normal school. She then attended Bemidji State Teachers' College. She married James Gilmore in 1934 and was clerk of Boy Lake Township for 50 years. She retired at age 70 after 49 years of teaching second grade.

ACROSS AMERICA, PEOPLE ARE DISCOVERING SOMETHING WONDERFUL. *THEIR HERITAGE.*

Arcadia Publishing is the leading local history publisher in the United States. With more than 3,000 titles in print and hundreds of new titles released every year, Arcadia has extensive specialized experience chronicling the history of communities and celebrating America's hidden stories, bringing to life the people, places, and events from the past. To discover the history of other communities across the nation, please visit:

www.arcadiapublishing.com

Customized search tools allow you to find regional history books about the town where you grew up, the cities where your friends and family live, the town where your parents met, or even that retirement spot you've been dreaming about.